MW00325050

IMAGES
of America

ITHACA RADIO

ON THE COVER: The WICB-FM Studios on Buffalo Street in downtown Ithaca are pictured in the 1950s. (Courtesy of C. Hadley Smith, Ithaca College.)

IMAGES
of America

ITHACA RADIO

Peter King Steinhaus
and Rick Sommers Steinhaus
Introduction by Keith Olbermann

ARCADIA
PUBLISHING

Copyright © 2014 by Peter King Steinhaus and Rick Sommers Steinhaus
ISBN 978-1-4671-2186-6

Published by Arcadia Publishing
Charleston, South Carolina

Printed in the United States of America

Library of Congress Control Number: 2013956888

For all general information, please contact Arcadia Publishing:
Telephone 843-853-2070
Fax 843-853-0044
E-mail sales@arcadiapublishing.com
For customer service and orders:
Toll-Free 1-888-313-2665

Visit us on the Internet at www.arcadiapublishing.com

CONTENTS

ACKNOWLEDGMENTS

Ithaca Radio has been a labor of love, and we hope you will enjoy these pictures and stories about the magic of Ithaca and how great voices and personalities got their starts there. Our thank-yous begin with everyone who contributed the pictures found in this book. Please note that their names have been placed at the end of corresponding captions. We are also grateful to those who found pictures that were not used in this book and to the many more people who looked, only to come up empty. We give thanks to the following people and organizations for their invaluable help: the Cayuga Radio Group; Connie Fairfax Ozmun and Wendy Paterniti, who saved photographs and memorabilia from oblivion; Saga Communications executive vice president Steve Goldstein; general manager Chet Osachey; and longtime broadcaster Rudy Paolangeli, whose prodigious memories and identification skills were undimmed by time! We also want to thank Ithaca College; Ithaca College Park School dean Diane Gayeski; April Johanns, the school's coordinator for student and external relations; student researcher Joseph Alpern; and Ithaca College archivist Bridget Bower. Many thanks go to Cornell University and Hilary Dorsch Wong, the Rare Manuscript Collection archivist at the Carl A. Kroch Library, who helped us navigate a system too complicated for most humans and all radio people. At Arcadia Publishing, thanks go to Remy Thurston, Rebekah Collinsworth, Abby Walker, and Jim Kempert.

Special thanks go to Peter Schacknow; the inimitable Keith Olbermann, who took the time to share his thoughts and memories for the introduction to this book; the many coworkers and mentors who helped us get started in Ithaca; and to our parents, Joan and Dick, who sent us to Ithaca in 1974 and 1978 and never once asked, "When are you going to get a real job?"

From Peter: A thank-you is given to Lisa Meyer Steinhaus, my wife and best friend, for her patience, guidance, encouragement, sense of humor, and her eagle eye for cleaning up my sometimes-spotty punctuation, typos, and run-on sentences!

From Rick: Thank you, Valerie, for your endless love, support, and encouragement through life's minefields.

INTRODUCTION

If this did not all actually happen on one day, it could have.

On some afternoon early in 1978, I could have stood up from my seat at my radio newswriting class at Cornell University and said goodbye to teacher Don Martin, thanking him again for giving me the only practical broadcasting advice I ever got in school—"Whenever I hear somebody say, 'Good morning, Ithaca,' or 'Hello, everybody,' on radio, I always turn around to see who's come in the room with me. You broadcast to *a* listener or *a* viewer. The crowd you imagine is vanity." My classmate Peter Schacknow, later of UPI, ABC, and CNBC but at that point our news director at WVBR-FM, could have joined me in wondering aloud how Mr. Martin was as entertaining as he was when the stations Cornell owned and for which he served as general manager, WHCU-AM and -FM, were not. Decades later, Mr. Martin would finally answer my question about how somebody as talented, deep-voiced, and gifted with perfect diction, had not advanced to national radio by smiling and saying quietly, "I liked it here."

Leaving Mr. Martin to defend his play-by-play rights to all the Cornell sports from our jealous, leering advances, Peter and I could have walked through Cornell's agriculture quad, then cut past the hockey rink and down toward the electrical engineering buildings, and finally across the bridge into Ithaca's Collegetown. When we got to 227 Linden Avenue, WVBR's home, we would have passed by the ramshackle offices of the *Ithaca New Times*, a weekly newspaper that rented our bottom floor. The term "rented" often required quotation marks—we would have doubtless cracked wise about its proprietor, known to the rawest trainee at VBR for not always paying on time. His name was Jay S. Walker, and he would go on to be a founder of Priceline and fund TED, and after the dot-com bubble burst in 2000, *Forbes* reported that his net worth was down to only $333 million.

Pete and I would pound up the loud, metal stairs to the studios on the second floor and buzz our way into the place. If our friend and soon-to-be program director Glenn Corneliess was not staring at us through the glass of the main studio, he would be found in the business office talking to somebody—on the phone, in person, in a large group, or one-on-one—about how to do radio correctly. After 18 years of being on the air and in management at stations from Binghamton to Long Island, Glenn was one of the wise young men of Katz Radio, again addressing the recruits on how to do radio correctly, when a congenital heart defect, of which he never knew, struck without warning and killed him before he collapsed to the floor. Gone nearly 18 years now, Glenn—with his older son already working in television—is still way ahead of the rest of us in life accomplishments, but I do not think he'd mind that, when I got the honor to name VBR's new studios on Buffalo Street, I dedicated them to him and my late father.

Somewhere near Glenn, we'd likely find Pat Lyons, promotions director, disc jockey, and a guy whose turntable operated a few RPM faster than everybody else. That winter in 1978, he and I were splitting the public address announcing for Cornell basketball when, groggy from an all-nighter, Pat announced, "Good evening and welcome to Cornell hockey." After the requisite

laugh, he apologized and went on to say, "Good evening and welcome to Cornell basketball," upon which the basketball crowd actually booed the reality that they were the basketball crowd. Pat is now Patrick J. Lyons of the international desk of the *New York Times* and looks more like an ambassador than a promotions director throwing Frisbees at his colleagues.

As the elected station executive in charge of the training program and all matters personnel, I would have to check all of "my" sheets on the station's bulletin board. There were sign-up sheets for training sessions for disc jockeys and sportscasters, and newscasters, and technicians, and the WVBR-FM official staff list, which I had to update (by typing it completely anew) each time another trainee passed his staff test. I would also have to retype it every time one of our "techies," Jon Rubinstein, would cross out his name and defiantly write in the only thing he ever answered to: Ruby. Like our senior tech guys John Hill and Andy Ingraham (who between them spent about 70 years working at VBR), Ruby could fix or repurpose anything. Yesterday's worn-out headphones would become tomorrow's remote patch cord. Ruby was great at that—a truth that Steve Jobs noticed just a few years later, after he had hired Jon J. Rubinstein but before Ruby created the iPod for him. Ruby went on to run Palm for a time and then part of Hewlett-Packard. I wonder if he would cross out his given name on whatever Silicon Valley equivalents existed for college radio staff lists.

At some point in these travels, Pete and I would've run into Phil Shapiro. Nothing and no one is forever, but Phil is a serious argument against that conclusion. He found a home at the station in the 1960s, selling advertising and producing a folk-rock show, *Bound For Glory*, that was so good it was performed in front of a live audience, had star guest performers travel to Ithaca specifically to play on it, and was syndicated to other stations. Phil is literally still there, probably nudging an advertiser or fretting about a guest or eating a sandwich.

While walking back toward the other end of the L-shaped hallway that hugged the air studios, one would make the obligatory pilgrimage past Larry Epstein's empty office. By this point, Larry was in his second term as general manager. He wasn't negligent; he just was always somewhere else doing something on behalf of VBR. In 1978, he also had to clean the mess I made during the three months I was his fill-in; I was no more suited to run a radio station at 18 than I am at 54. Larry and newscaster Karen Hasby were the station's power couple, and a power couple they are still. Karen had a long stint as a newscaster on Channel 11 in New York, and all during those years, Larry told us he was the secret CEO of CBS Television. Today, Larry has escaped for the life academe at Drexel.

Larry's program director was Andy Denemark, who set some kind of record by offering me two jobs, 21 years apart. It was Andy who turned to me to be sports director after Tim Minton (20 years a reporter at Channel 4 in New York) left the station, and later, he wanted to syndicate commentaries from me for United Stations Radio where he is still vice president and still looks disarmingly like the guy I said yes to in 1976.

Gliding about the newsroom, 20 feet past Larry's vacant office, would have been the lithe figure of Carol Hebb, who had buzzed the front door late the previous summer and announced to Peter and me that she wanted to be a newscaster. We had her read a piece of UPI wire copy aloud, and she did it flawlessly. I said, "I think you already are a newscaster." In fact, that night, she was already at network-level quality and would be at UPI in less than two years and at ABC News a year after that. As likely as not, our newscaster and community affairs director Andy Grossman was known to rush through the newsroom, picking up a station tape recorder or dropping one off, on his way to hearings or presentations of governmental arcana. Andy's spent 35 years covering news and then covering the coverage of news for outlets like Broadcasting & Cable. By this time, one of our 1977 news trainees would've just been coming into her own; Stacey Cahn went on to make a career of it at WNEW-FM in New York and at NBC News.

People whose presence was still very much felt in the studios had trained most of us veterans in news and sports. Joel Meltzer had left VBR to work first downtown at WTKO and then in Syracuse. Pam Coulter had been the definition of professionalism and moved directly into the CBS News family; if you turn your radio on at the top of any hour, you'll likely hear her doing

the CBS network newscast. The late Bruce Hagan was on his way to produce for NBC's *Dateline* and lead the newsroom at Channel 5 in New York. But to us, he was the guy who conducted "copy clinic," which was a one-on-one tutorial with countless would-be announcers who had diction flaws or accents or other problems reading aloud. After weeks working with Peter, Bruce told him to forget about becoming an announcer because Peter would never exorcise the Long Island in his voice. This conversation reached its perfect conclusion more than a decade later when Bruce was looking for work and found himself applying to Peter and breaking the silence by announcing: "So I guess I was wrong about that."

For our generation and the generations around us in the VBR newsroom, following Andy Grossman's lead and doing the grunt work at the various Ithaca town meetings forged a tradition of surprisingly excellent noncollegiate local news. But the failsafe on that front was to listen to the WTKO newscast just before the top of each hour to hear what we had missed. Nearly every one of them was done by Bob Lynch or his sister Marcia, themselves VBR alums. In the summer of 1977, TKO's wire machine broke, and Peter and I got the surprising, plaintive phone call from Bob Lynch asking for a little help. Sure enough, minutes later, there was Bob, rescuing our discarded wire copy from a huge garbage can; he was literally picking through VBR's trash for TKO's news. It was the only time he had to do that, but naturally we loved it.

With Carol Hebb running off to do the 4:15 newscast, a little cream-colored AM clock radio in our newsroom would come into view. It could pick up WTKO and WHCU and absolutely nothing else, but it had been the conveyor of the first great lesson of my career. For my first year, I had, like everybody else, simply ripped the UPI sports copy and read it as written, dropping in a local result now and again. But on one particularly slow night when my five minutes of dehydrated sports news had been ordered into what I thought was the descending order from most important to least, I decided to check if I had missed something and listened to TKO's sportscast, which aired 45 minutes earlier than mine. The fellow there had something of a lisp and a singsong delivery, but more alarmingly, he had ordered his five minutes of UPI copy exactly the same way I had. His sportscast was, word-for-word, identical to mine. Right then, it occurred to me that I wasn't going to succeed just because he had a lisp and I didn't. I rewrote as much of that sportscast as time permitted and haven't stopped writing since.

If it were early enough in the year and late enough in the day, Pete and I might have tuned that radio to WHCU to hear the stately, stentorian Roy Ives call a Cornell hockey game. Or had we been listening to one of the Lynches, we might have spent a few minutes listening to the fast-talking disc jockey, another Peter, who just happened to go on to CBS News and write this book.

On our prototypical 1978 afternoon, radio in Ithaca was dynamic and strange. The Ithaca College station, WICB, matched us at VBR stroke-for-stroke when it came to music programming. We didn't know Bob Buchmann, who would go on to revive classic rock at WAXQ in New York, but he was there. ICB had superior facilities and a nice niche inside the college structure, but it couldn't sell advertising time. Because of a bizarre experiment launched by the FCC, licenses had been granted at the eight Ivy League schools, and WVBR was a hybrid. WVBR could sell commercials, and individual students could make a few pennies by producing the spots or convincing advertisers to buy them, but the station had to plow the rest of the cash back into its budget. Thus for the school year of 1978–1979, WVBR would sell around $250,000 in ad time, and a guy at the station who made a new commercial every week might earn about $100.

There was a kind of serious rivalry in town between the collegiate broadcasters, the strange Hippogriff that we were at VBR, and the pure professionals. My professor Don Martin once accused me of "trying to take the bread out of the mouths" of his employees by seeking the rights to broadcast any Cornell sports events he didn't want to carry. I told him that if his employees took some of the bread out of their mouths, WHCU wouldn't sound quite so stuffy, and he laughed uproariously.

Looking back 35 years, it is stunning to see all the names, all the successes-to-be, crowded into one small city in New York's Central Southern Tier. I haven't even gotten into all the people all of us at VBR (and TKO and HCU and ICB) covered—Cornell figures ranging from Dr. Carl

Sagan, who, on the day he won his Pulitzer Prize, would only, for reasons I still don't understand, be interviewed by me and only live; to the athletic director Dick Schultz, the future head of the NCAA and then the US Olympic Committee; and to the success-free football coach George Seifert, who had been fired in 1976 but whose next year as a head coach anywhere would see him win the Super Bowl with the San Francisco 49ers. Christopher Reeve was at Cornell then and legendarily bombed out of copy clinic, and Bill Nye attended Cornell too. And then there was the time that a skinny kid argued his way ahead of our prescheduled interview with the comedian performing on campus, Robert Klein. I vowed that I'd always remember him, and it was 30 years later when he and I stood together at the after-party for his HBO show that Bill Maher finally realized he had been the argumentative skinny kid.

I was in Ithaca from August 1975 through May 1979, and the collective concentration of talent and opportunity and ambition has never been exceeded at any stage of similar length in my career. And just from my own time, I've left out a hundred other names you might know or remember very well, to say nothing of the hundreds and hundreds who have made Ithaca the biggest small radio market in the world.

"Market size" bends and reshapes as the decades go by. In my time, Ithaca was the 351st largest in the country. From the memories, and the air-check tapes, I know in my heart that Ithaca radio then was better than any of the top 10 largest now, and it is a privilege to have a small place in this documentation of just how good it was, just as it was a privilege to have been on the air there.

—Keith Olbermann

One

WHCU

The year 1923 was when Lou Gehrig and Babe Ruth christened a brand-new ballpark known as Yankee Stadium. Warren Harding was the 29th president of the United States, gas was approximately 25¢ a gallon, and the Dow Jones Industrial Average was at about 105.

Here in Ithaca, WHCU went on the air for the first time on June 23 of that year. The station, which originally was a Cornell University "experiment" as far back as 1912, was known as 8YC, eventually becoming 8VU.

By 1932, Cornell was partnering with the *Elmira Star Gazette* sharing programming on WEAI. By 1940, the FCC allowed the station to become WHCU at 870 on the AM dial. The station's first studios and offices had been on campus. WHCU, the "Home of Cornell University," stayed in this location until 1940, when new studios were built on the fifth floor of the Ithaca Savings Bank downtown. In 1957 WHCU moved to State Street, above the College Spa Restaurant, and remained there until 1990.

A full-service community-minded broadcaster, WHCU served up local news and sports (Big Red basketball, hockey, and lacrosse) as well as local interviews, and was supported on a national level by the CBS Radio Network. That relationship still exists today.

The station and its sister station, WYXL, were packaged and sold to Eagle Communications in 1985.

Twenty years later, the group—now including WQNY-FM, WNYY 1470 AM, WIII 1-100 (formerly WNOZ), WYYS, WNYP-FM, and WOKW—was spun off to Saga Communications, which manages the Cayuga Radio Group from its facility on Hanshaw Road.

GENERAL ELECTRIC COMPANY
GENERAL OFFICE SCHENECTADY, N. Y.

1 River Road
SCHENECTADY, N. Y.

June 4, 1929.

Prof. W. C. Ballard,
Cornell University,
Ithaca, New York.

RE: Installation of Broadcasting
Station for Cornell University,
Ithaca, N.Y. File SYR-3379½

Dear Prof. Ballard:

All items of material which are being supplied from
Schenectady for your installation have now been shipped with
the exception of the antenna wire which was shipped from
Trenton, N.J. May 20th but has not yet arrived at Schenectady.
This item is being traced but in the event it is not available
at the time the antenna would actually be used, a temporary
antenna may be erected from available materials for test
purposes.

Item D originally specified 750 feet of #14 wire but
this was changed to 2000 feet.

We await your advice as to when our supervising engineer
should arrive at Ithaca. It is suggested that you complete
the installation of the wire ground, locate the transmitting
apparatus in final position, pull the conductors through the
conduit, and complete the power supply to the building. At
the completion of these items, upon your notification we will
send a supervising engineer. The remaining work should require
only two or three days time to complete.

Please do not hesitate to call on us if we can assist
in any manner in connection with this work.

Very truly yours,

W. W. Brown

RADIO ENGINEERING DEPARTMENT

WWBrown:MLD
WKDunlap

This 1929 letter from General Electric details orders for some of Cornell University's early broadcasting equipment used by the predecessor to WHCU. Talk about customer service! (Courtesy of Cayuga Radio Group.)

WHCU actually began as WESG, broadcasting with 1,000 watts at 1270 AM, in 1932. This is Cornell University's first broadcast license, authorizing it to operate WESG-AM from sunrise to sunset, with its main studios at the Mark Twain Hotel in Elmira and transmitting facilities at Cornell. (Courtesy of Rudy Paolangeli.)

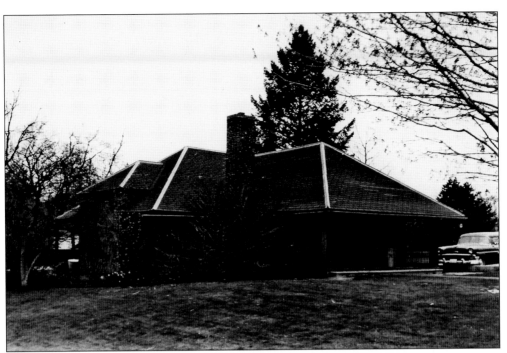

The Countryman Building at Cornell University was WHCU's home from the first sign-on until 1940. (Courtesy of Rudy Paolangeli.)

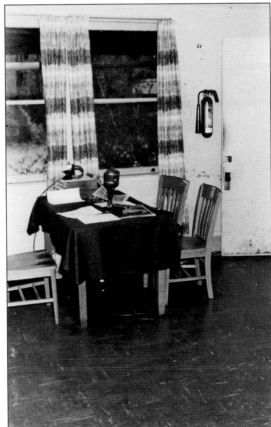

Talk about humble beginnings! This is where it all began for WHCU—in a single, sparse broadcast studio inside Cornell University's Countryman Building. (Courtesy of Rudy Paolangeli.)

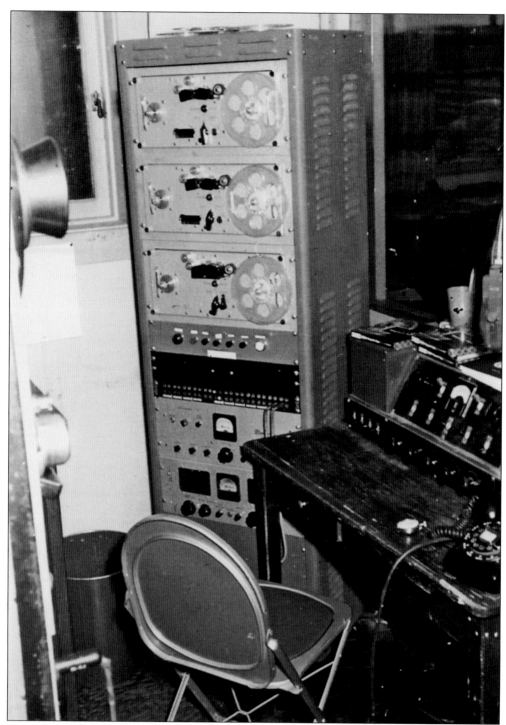

Pictured is WHCU's control room in the Countryman Building at Cornell University. The Western Electric console on the right was installed in 1936, and the recording equipment to the left was put in during the 1950s. This facility was used for programs originating on Cornell's campus well after WHCU moved downtown in 1940. (Courtesy of Rudy Paolangeli.)

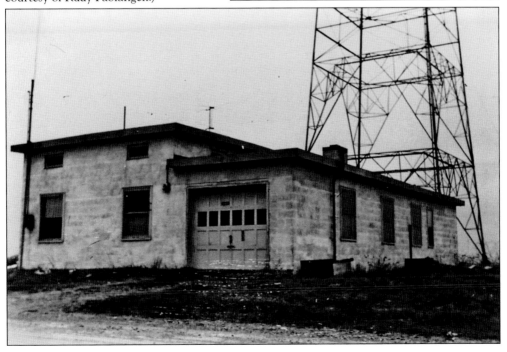

Here is WHCU-AM's original transmitter site. The transmitter broadcast from a 355-foot-tall tower on Mount Pleasant. The mountain itself is more than 1,700 feet high. Until October 1986, WHCU-AM was a daytime-only station, signing off at sunset to protect WWL New Orleans, which still broadcasts on the same 870 AM frequency. WHCU-AM now broadcasts 24-7 from four towers in Newfield, New York. (Both, courtesy of Rudy Paolangeli.)

15

In 1940, WHCU left Cornell University's campus for the fifth floor of the Ithaca Savings Bank Building, at the corner of North Tioga and Seneca Streets. This was WHCU's home until June 1957. (Courtesy of Rudy Paolangeli.)

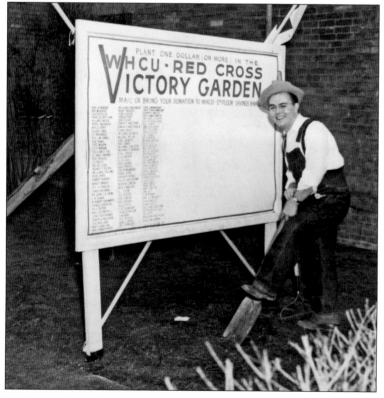

Jack Deal woke up Ithacans as WHCU's morning man from February 9, 1941, to September 16, 1981. When he announced his retirement, the *Ithaca Journal* described Deal as "a gentle and modest man who goes out of his way not to hurt people." He is shown here in a 1942 promotional picture for the station's Victory Garden during World War II. (Courtesy of Cayuga Radio Group.)

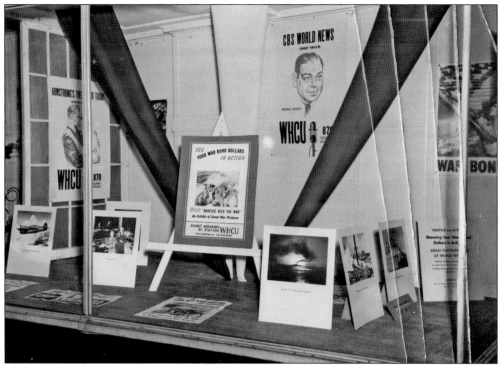

Like most broadcasters during World War II, WHCU supported the war effort by promoting the sale of war bonds. This 1944 display includes promotional posters for a World War II photography exhibit and CBS Radio Network news broadcasts. (Both, courtesy of Cayuga Radio Group.)

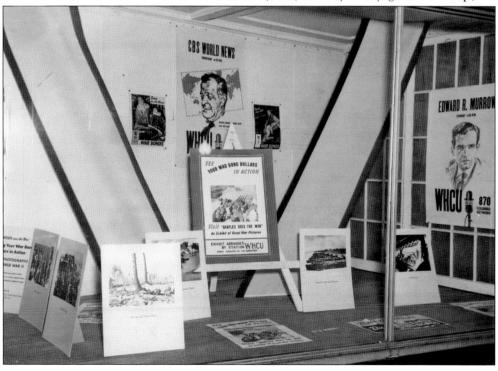

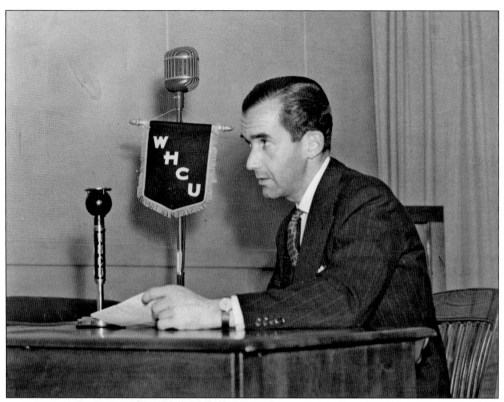

Legendary CBS News correspondent Edward R. Murrow is seen broadcasting from WHCU. This photograph was labeled as "1940," but research has discovered that Murrow was actually in London that year, reporting on Germany's relentless bombing of the British. This photograph was likely taken in January 1942, when he spoke at Cornell's Bailey Hall to raise money for the American Red Cross emergency fund. (Courtesy of Cayuga Radio Group.)

It appears that this WHCU announcer, preparing for a newscast, sees something he likes on the United Press teletype in the early 1940s. Note the United Press "War Maps" on the wall to the left. (Courtesy of Cayuga Radio Group.)

Remote broadcasts have always been a radio staple. Here is WHCU's location at the 1944 Cortland County Fair. The huge photograph at center shows morning host Jack Deal. The small sign to his upper right promotes WHCU's *Radio Theatre*. The poster at right center promotes CBS News foreign correspondents near the climax of World War II. (Courtesy of Cayuga Radio Group.)

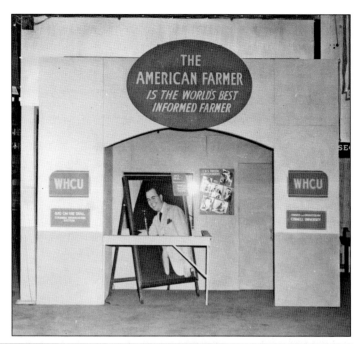

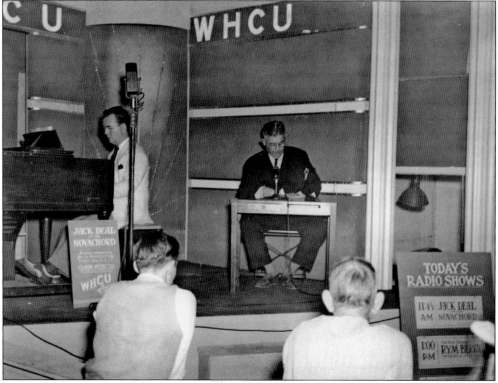

Here, WHCU morning man Jack Deal is seen performing live at the piano from the 1944 Cortland County Fair. The piano was provided by Ithaca's Clark Music Company. The sign at lower right promotes other WHCU personality appearances, including "Farm Philosopher" Rym Berry. (Courtesy of Cayuga Radio Group.)

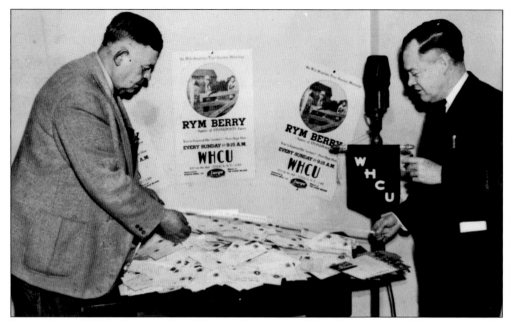

Pictured around 1944, Romeyn "Rym" Berry, left, was one of WHCU's earliest and most memorable personalities. The attorney and longtime Cornell sports official was known as the "Farm Philosopher," writing commentary for WHCU, the *New Yorker*, and the *Ithaca Journal*. In April 1946, the *Cornell Daily Sun* reported that "his Sunday morning program . . . holds a listening audience, second to none in loyalty." (Courtesy of Cayuga Radio Group.)

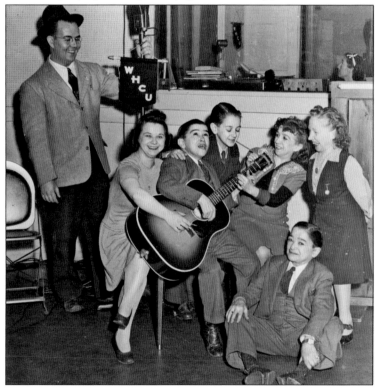

Live music was one of the hallmarks of radio's golden age. Seen here in 1943, morning man Jack Deal hosts a group called the Seven Dwarfs, although one appears to be missing! (Courtesy of Cayuga Radio Group.)

Live radio drama was also a hallmark of the medium's golden age. These undated photographs show actors at work at WHCU. (Both, courtesy of Cayuga Radio Group.)

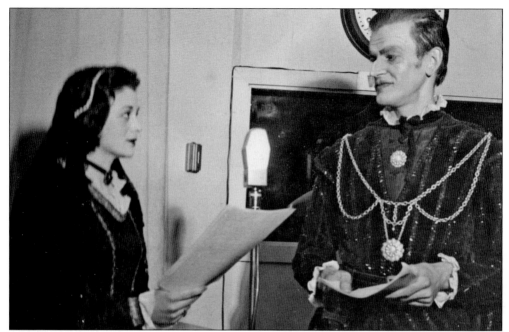

Even though listeners could not actually see them, WHCU radio actors, as well as others, often dressed the part for their plays. Lillian Cardiff (left) and Walter Leamer are performing Shakespeare. (Courtesy of Cayuga Radio Group.)

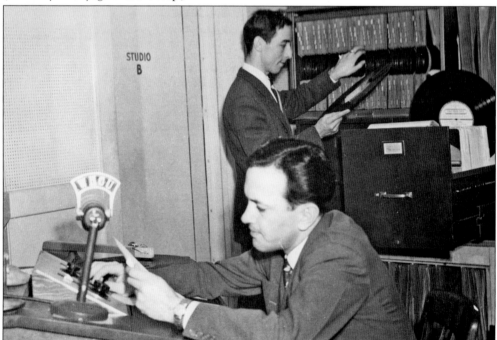

As Ithaca College established its radio curriculum, its students produced radio dramas at WHCU-FM. In the studio, the Ithaca College Workshop Players performed 30-minute dramas on Thursday nights in April 1948. The shows aired on WHCU and were also recorded for later playback on other stations around New York state. (Courtesy of Park School of Communications, Ithaca College.)

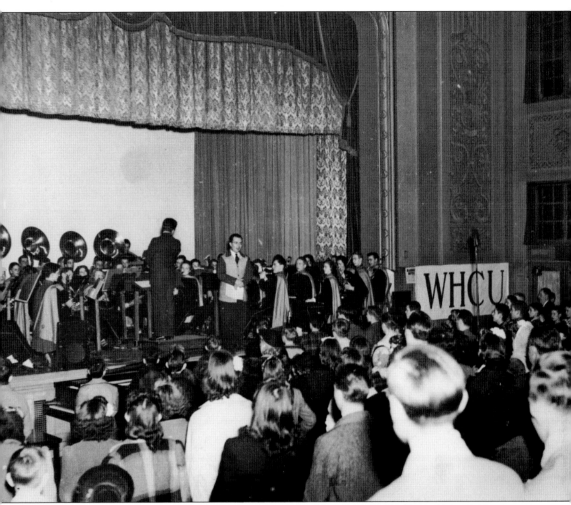

WHCU *Radio Theatre* is performing live at the Cortland County Fair in the mid-1940s. (Courtesy of Cayuga Radio group.)

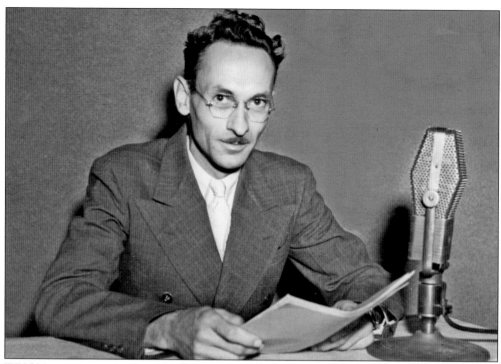

WHCU's 1,000-watt daytime AM signal reached much of central New York's farming community. In the 1940s, Cornell University agriculture specialist Elmer Phillips was among the announcers who delivered the station's daily farm reports. Phillips also doubled as the public address announcer for Cornell's home football games. (Courtesy of Cayuga Radio Group.)

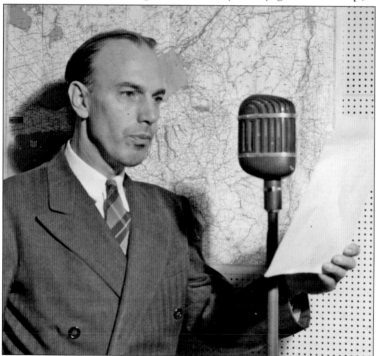

WHCU's Lou Kaiser also delivered agriculture reports during the 1940s. (Courtesy of Cayuga Radio Group.)

The WHCU studio control room is seen in the mid-1940s. (Courtesy of Cayuga Radio Group.)

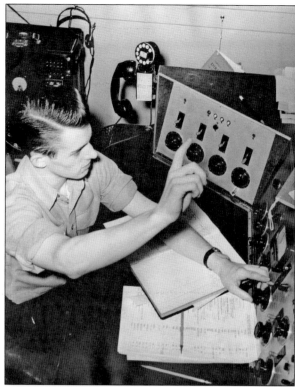

Gertrude Grover was WHCU's women's editor during the 1940s and 1950s and also hosted a weekly program spotlighting senior citizens. She is pictured behind the WHCU "8 Ball" microphone. (Courtesy of Cayuga Radio Group.)

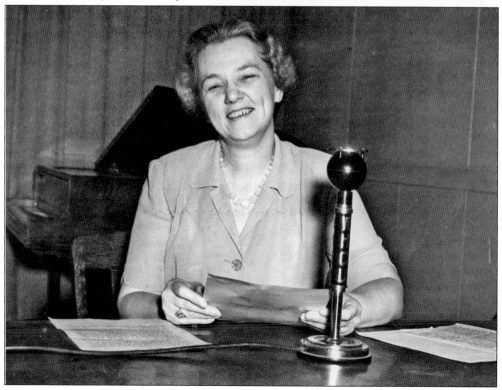

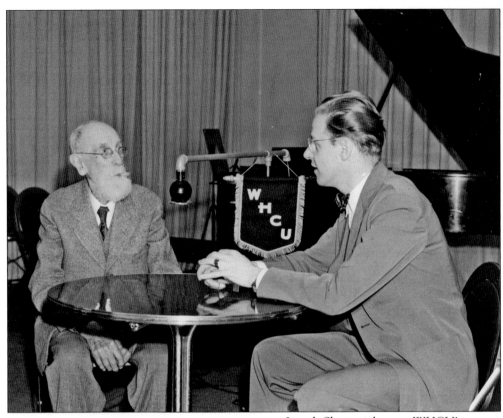

Joseph Short, right, was WHCU's program director during the 1940s. He is shown interviewing an unidentified Cornell professor. (Courtesy of Cayuga Radio Group.)

WHCU announcer Paul Hadley is pictured in the mid-1940s. (Courtesy of Cayuga Radio Group.)

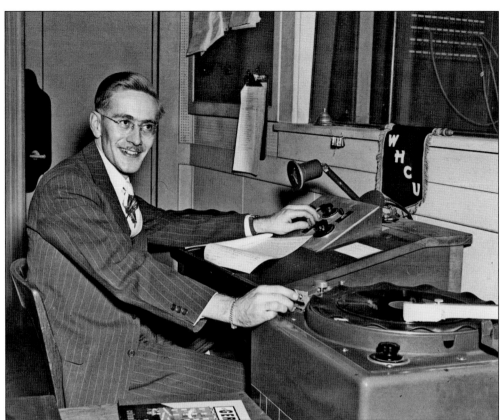

WHCU personality Preston Taplin is seen in the 1940s. He was not always smiling. In March 1946, the *Cornell Daily Sun* reported that Taplin wrote a *Broadcasting Magazine* article that criticized American radio programming from a returning GI's point of view. (Courtesy of Cayuga Radio Group.)

WHCU's Preston Taplin hosted *Time for Taplin* during the 1940s. In 1946, the show was 40 minutes long and sandwiched between *Masterworks of Music* and news, according to a schedule published in the *Cornell Daily Sun*. (Courtesy of Cayuga Radio Group.)

The WHCU newsroom is pictured in the late 1940s. To the left is a "New York State Highway Conditions" map. To the right, a sign reads, "Work is the curse of the drinking class!" (Courtesy of Rudy Paolangeli.)

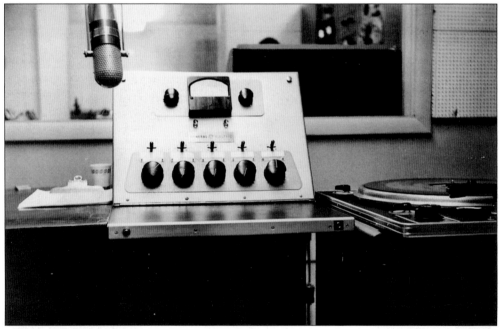

This is a WHCU studio in the late 1940s. The switches on this five-channel General Electric console allow the operator to put live announcers and recorded material on the air. The turntable has a 16-inch platter, which was big enough to handle the electronic transcription discs that were common at the time. The RCA 77DX microphone is a classic; these days, one in working condition is worth thousands of dollars. (Courtesy of Rudy Paolangeli.)

AM ruled the early radio airwaves, but on October 19, 1947, WHCU-FM went on the air. This program guide shows the FM antenna and tower, signaling a new era for Ithaca radio broadcasting. (Courtesy of Rudy Paolangeli.)

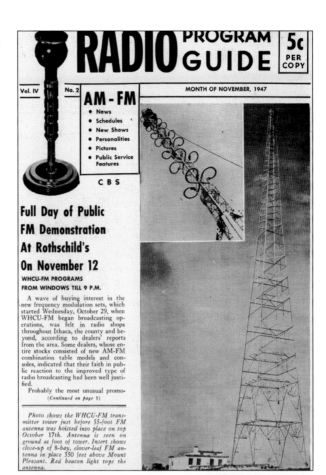

RADIO **PROGRAM** GUIDE 5¢ PER COPY

Vol. IV No. 2 **AM - FM**
- News
- Schedules
- New Shows
- Personalities
- Pictures
- Public Service Features

MONTH OF NOVEMBER, 1947

C B S

Full Day of Public FM Demonstration At Rothschild's On November 12

WHCU-FM PROGRAMS FROM WINDOWS TILL 9 P.M.

A wave of buying interest in the new frequency modulation sets, which started Wednesday, October 29, when WHCU-FM began broadcasting operations, was felt in radio shops throughout Ithaca, the county and beyond, according to dealers' reports from the area. Some dealers, whose entire stocks consisted of new AM-FM combination table models and consoles, indicated that their faith in public reaction to the improved type of radio broadcasting had been well justified.

Probably the most unusual promo-
(Continued on page 5)

Photo shows the WHCU-FM transmitter tower just before 55-foot FM antenna was hoisted into place on top October 17th. Antenna is seen on ground at foot of tower. Insert shows close-up of 8-bay, clover-leaf FM antenna in place 350 feet above Mount Pleasant. Red beacon light tops the antenna.

Before tape, many radio programs were recorded on electronic transcription discs, called ETs, for playback. This is a WHCU recording of Jack Deal's *Memory Time* show, during which he sang and played piano or organ. He also read poems and stories, many provided by his listeners. The show aired during the late 1940s. (Courtesy of Rudy Paolangeli.)

WHCU
ITHACA, NEW YORK
LATERAL CUT
NAB LATERAL RECORDING CHARACTERISTIC
Inside START
RPM 33⅓ 78
USE NEEDLE DESIGNED FOR ACETATE
Jack Deal's Memory Time
Program _____ Part TWO
To Be Played _____ Time _____
Talent _____
Recorded _____

WHCU-AM's 1,000-watt Raytheon transmitter was installed in 1948. (Courtesy of Rudy Paolangeli.)

Sam Woodside was WHCU's sports director from 1945 through the early 1970s, delivering sportscasts and handling play-by-play for Cornell football, hockey, and more. Woodside also hosted a Sunday morning news program, *Radio Edition of the Weekly Press*. In 1978, Cornell awarded Woodside its prestigious Ben Mintz Media Award in honor of his long career. (Courtesy of Cayuga Radio Group.)

Joan Blum (left) was one of two Ithaca College student interns at WHCU in April 1948. Her mentor was Barbara Hall (right), a then-recent Cornell graduate hired as WHCU's continuity director. Hall would succeed the retiring Gertrude Grover as WHCU's women's editor in the 1950s. (Courtesy of Park School of Communications, Ithaca College.)

The elephant in the room is supposed to be there! The interviewer is Gertrude Grover, WHCU's women's editor during the 1940s and 1950s. This picture was taken at the station's Ithaca Savings Bank Building studios during the early 1950s. It is not known how they got the pachyderm into the elevator for the trip up to the fifth floor or the trip back down. (Courtesy of Cayuga Radio Group.)

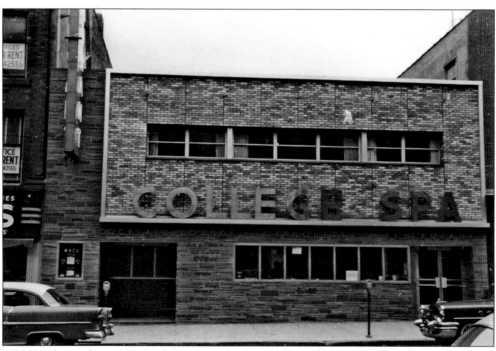

WHCU's home from 1957 until 1990 was the second floor of this building, above the College Spa Restaurant on State Street. This area became the Ithaca Commons in the mid-1970s. The WHCU entrance was to the left. (Courtesy of Rudy Paolangeli.)

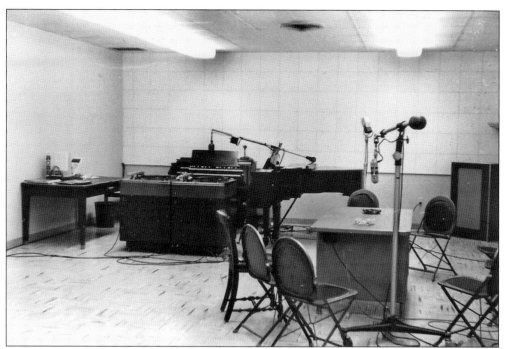

WHCU Studio A was well equipped during the 1950s. The piano, organ, and turntables were primarily for morning man Jack Deal. There was a singer's mic at the foot of the piano, and there was also a boom mic, with table and chairs, for talk segments. An engineer played recorded commercials and breaks from a control room. (Courtesy of Rudy Paolangeli.)

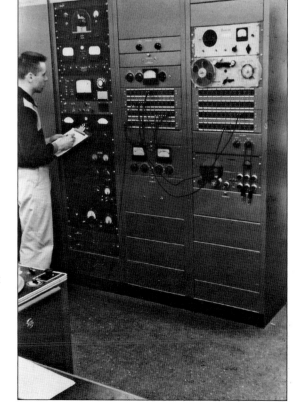

WHCU-AM remote-control equipment for the transmitter is pictured in the late 1950s. The reel-to-reel tape deck may have been used to record the station's on-air signal or for emergency playback capability. The cables and panels enabled engineers to "patch" different studios to go on the air. (Courtesy of Rudy Paolangeli.)

Pictured in late 1950s is a bank of Ampex tape decks inside the WHCU control room. They were used for the recording and playback of programs. (Courtesy of Rudy Paolangeli.)

To anyone under 20, this may look like it belongs in Dr. Frankenstein's lab. In reality, it is the WHCU-FM transmitter in the late 1950s. This was long before transistors and integrated circuits shrank the size of these powerful beasts. Radio geeks may recognize the driver unit at left and the power unit to the right. (Courtesy of Rudy Paolangeli.)

Roy Ives was a WHCU mainstay for nearly 30 years. From 1963 to 1980, he was a classical music host on WHCU-FM and did play-by-play for Cornell hockey (with longtime program director Tom Joseph) and lacrosse. He was the general manager at WTKO from 1980 to 1982 and then returned to WHCU for nine years to broadcast hockey and serve as news director. He is shown here as an Ithaca College student, learning his craft at WICB. (Courtesy of Jack Mindy.)

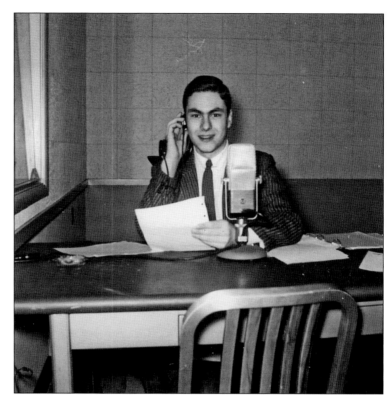

It's Apple Time Again!

We will be adding Barbara Hall of Radio Station WHCU to your sales staff starting September 17th.

She will be selling Apples to *your* customers with that sparkling personality that has made her so popular with listeners.

Western New York Apple Growers Association schedule starts September 17th and continues with ever increasing frequency into December.

This 1962 promotional sales piece features Barbara Hall, one of Ithaca's most beloved radio personalities. Hall joined WHCU in 1948 and stayed on the air until 2007. For years, Hall hosted a daily music and interview program from 10:00 a.m. to 12:00 p.m. and served as the station's women's editor. She also hosted nearly 1,000 editions of *Travel Talk* until her retirement at age 85! (Courtesy of Cayuga Radio Group.)

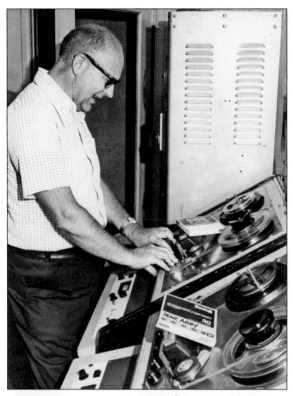

WHCU control room engineer Bob Stevenson, shown here in the 1970s, is cuing up a reel-to-reel tape either to be played directly on air or to be copied to a tape cartridge for easier playback convenience. In the foreground is a tape containing the day's segment of *Dear Abby* from the CBS Radio Network. (Courtesy of Cayuga Radio Group.)

WHCU's Bob Stevenson engineered Jack Deal's morning show from 1948 to 1978. Deal's studio is on the other side of the glass in front of Stevenson, and in this photograph from the mid-1970s he appears to be cuing the host to start talking, or perhaps he is just reaching for a tape or stretching his fingers. (Courtesy of Cayuga Radio Group.)

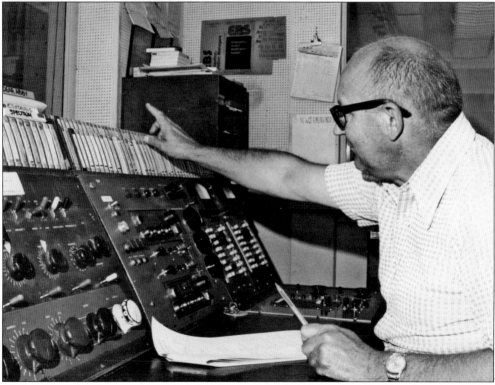

Jack Deal's morning show was broadcast from Studio A, seen here in the mid-1970s. He made his mark singing and playing the piano and organ; both instruments are pictured. Listeners loved his congenial nature, but when he retired, he told the *Ithaca Journal*: "They've put up with me for more than 40 years. That's a long time." (Courtesy of Paul Harvey.)

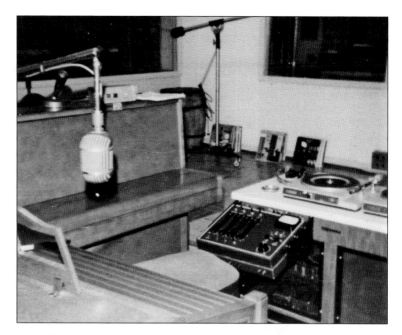

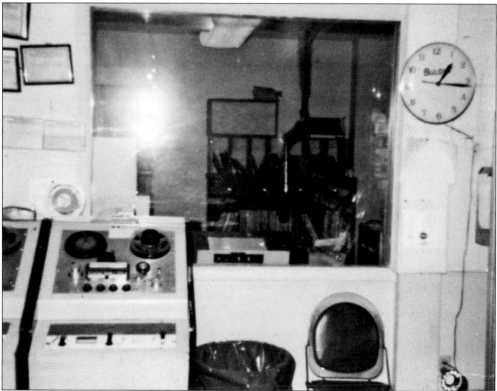

WHCU's master control room is seen in the mid-1970s. The master control room looked into Studio C. Engineers working in this room could switch different studios to feed WHCU-AM or -FM, depending on the need. Pictured here are an Ampex reel-to-reel tape deck and the engineers' framed FCC licenses on the wall. (Courtesy of Paul Harvey.)

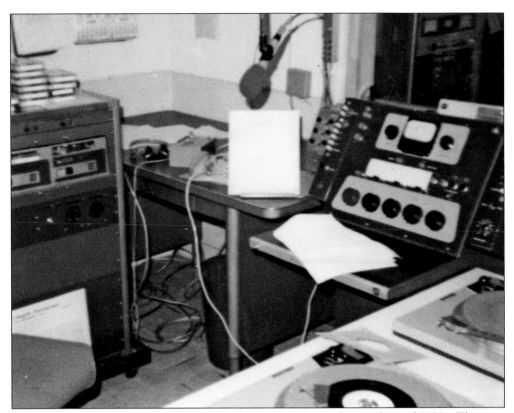

WHCU's Studio C contained a mixture of the old and new during the mid-1970s. The tape cartridge machines to the left represented the new, and an audio control board, built in the 1950s by engineer Bob Denison, represented the old. (Courtesy of Paul Harvey.)

WHCU-FM established a Black Affairs Department in 1971 to answer the growing demands and needs of the African American community. *Nightsounds* was a late-night program that combined music, news, and interviews. This mid-1970s bumper sticker was fluorescent red-orange. Some 20 years of *Nightsounds* tapes can be found at Cornell University's Division of Rare and Manuscript Collections at the Carl A. Kroch Library. (Courtesy of Paul Harvey.)

Rudy Paolangeli has been on the air in Ithaca since the 1950s, mostly at WHCU. He was also a sales representative and, later, sales manager. He taught at Ithaca College, too. In 1981, he succeeded morning host Jack Deal while doubling as general manager. Rudy retired from full-time duty in 1988. Starting that year, he hosted a Sunday morning nostalgia program, *The Rudy Paolangeli Show*, which celebrated its 25th anniversary in 2013. (Courtesy of Cayuga Radio Group.)

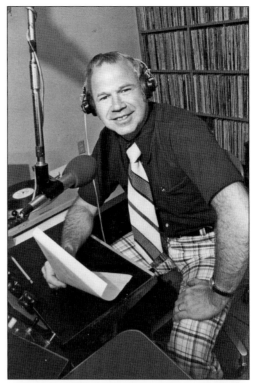

Howard Cogan (left) was one of Ithaca's most enduring voices and most loved media professionals. WHCU hired him as an announcer in 1943—when he was just 14! As an adult, Cogan started his own ad agency, voiced thousands of commercials, and created the famous "Ithaca is Gorges" slogan and logo. Howard also taught at Ithaca College. He is pictured here in the 1980s with his wife, Helen, and Ken and Allie Cowan, the post-Cornell owners of WHCU and Eagle Broadcasting. (Courtesy of Wendy Paterniti.)

Here, the CBS Radio Network congratulates WHCU for 50 years as a CBS affiliate. From left to right are CBS Radio vice president and general manager Michael Ewing, WHCU general manager Rudy Paolangeli, and CBS Radio senior vice president Dick Brescia. This picture was taken during the network's annual affiliates meeting at New York's Waldorf Astoria hotel in October 1985. (Courtesy of Rudy Paolangeli.)

Casey Stevens hosted the afternoon *Call Casey* show from 1991 to 1996, and then, mornings for a decade. The *Lansing Star* website called him "opinionated and sometimes tart," but always courteous to his guests. A listener donated her personal Casey Stevens T-shirt, shown here, to WHCU for its 90th anniversary in 2013. (Courtesy of Lee Rayburn.)

This 70th anniversary sales piece from 1993 details the early days of the station that eventually became WHCU. (Courtesy of Rudy Paolangeli.)

Barry Leonard, second from left, was WHCU's sports director for five years during the 1980s. He left to produce fellow Ithaca College alum Chuck Wilson's Providence, Rhode Island, radio talk show but came back to Ithaca and WHCU in the early 1990s. In 2013, he completed his 19th season as the play-by-play voice for Cornell football and lacrosse and began his 22nd season of Cornell basketball. He is shown here in 2013, celebrating his 1,000th hoops broadcast with, from left to right, Cornell University lacrosse head coach Matt Kerwick, basketball coach Bill Courtney, and football head coach David Archer. (Courtesy of Cornell University.)

1923-1993: WHCU Marks 7 Decades of Service

RETURN ALL

RUDY PAOLANGELI
324 South Geneva Street
Ithaca, New York 14850-5418
(607) 273-5773

(We are indebted to former General Manager Rudy Paolangeli for the substance of this broadcasting operations history at WHCU.)

A broadcast facility was begun in 1912 on an experimental basis as "station 8YC" in the School of Electrical Engineering at Cornell University. The number was later changed to "8XU" and a broadcast license was issued on May 27, 1922 by the Bureau of Navigation's Radio Division, Department of Commerce. Sequentially-issued call letters WEAI were assigned to the new Ithaca station, which took to the air on January 23, 1923. The University said its call letters stood for "We Educate And Instruct." The 1100-watt radio station was one of the first in the United States.

The station's original programming was 100% educational and agricultural, used mainly as a vehicle for the New York State/Cornell University Extension Service. By 1924 the "Class A" station reported an "irregular program schedule" was being maintained. On September 7, 1927, WEAI's license expired and broadcast activities were terminated; Cornell informed the Federal Radio Commission that it planned to resume broadcasting at a later date pending technical improvements and requested that the WEAI call letters be reserved. After building a new transmitter in the middle of a chicken yard (and two new 165-foot towers) its renewal application in 1929 stated that phonographic or mechanical reproductions were used occasionally, announced on the air as "phonographic reproductions." (By 1931, these were described as "phonographic records.") The station's programming had also taken on a more modern and ambitious character, by adding educational programs as well as a noon hour devoted to interests of the New York State Colleges of Agriculture and Veterinary Medicine,

and a late afternoon "University Hour" that presented campus-wide news and issues.

The next year, WEAI was granted permission to increase its power output from 500 to 1,000 watts--and to broadcast after midnight from time to time. Its 8-member University Radio Committee recommended hiring a salaried professional staff to produce daily programs, building a studio separate and apart from classroom activities, and selling advertising time to help pay for operating costs. To keep University and commercial interests separate, they suggested Cornell colleges reserve whatever programming time they thought they needed for educational programs, and only the remainder was to be offered for sale. In fact, they also decreed commercial programs were not to originate in the campus studio--and could not use the call letters WEAI.

The following year WEAI adopted the committee's recommendations. To gain a professional staff, the station was leased to the broadcasting division of the Elmira Star Gazette. Educational broadcasting under the

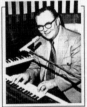

All of central New York awoke to the music and gentle whimsy of WHCU's legendary Jack Deal. (From a newspaper article in 1955)

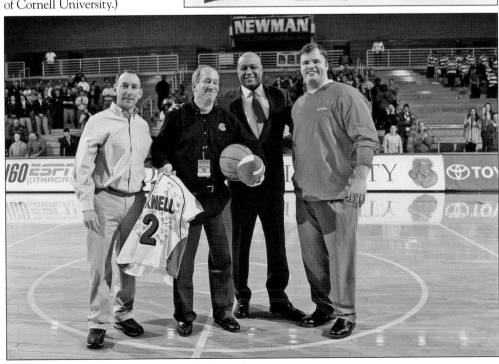

41

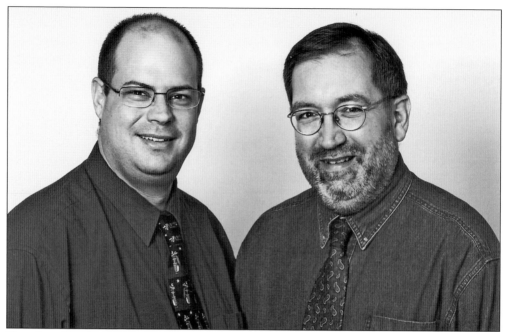

Host Dave Vieser and news director Geoff Dunn made up WHCU's morning team from 2006 to 2012. Dunn continued to host mornings after Vieser's departure. Dunn served as WHCU's news director for about two decades before leaving for a position with Tompkins County. (Courtesy of Cayuga Radio Group.)

In a business known for its turnover, WHCU has had only seven morning hosts since 1941! They include Jack Deal (1941–1981), Rudy Paolangeli (1981–1988), Jerry Angel (1988–1996), Casey Stevens (1996–2006), Dave Vieser (2006–2012), Geoff Dunn (2012–2013), and finally, Lee Rayburn, shown here (left) with news director Greg Fry during WHCU's 90th anniversary year in 2013. (Courtesy of Cayuga Radio Group.)

Two

WICB

Michael R. Hanna established the Ithaca College radio department in downtown Ithaca in 1941, and WICR was born.

After six years at 120 East Buffalo Street, the radio department moved to West Court Street. At this time, Ithaca College applied to the Federal Communications Commission (FCC) for a noncommercial educational broadcast license. In 1949, the FCC granted this license under the call letters WITJ on the FM dial at 88.1. The FCC reassigned the frequency to 91.7 after complaints from residents about signal interference with their televisions.

Eight years later, Ithaca College opened a new broadcast center in downtown Ithaca at 124 East Buffalo Street, and the FCC granted permission for a call letter change to WICB ("Ithaca College Broadcasting").

That same year, WICB-FM's little AM brother was born. Broadcasting limited hours, the station was licensed to do so via carrier current. In 1964, the AM station expanded its programming from 4:00 p.m. to midnight, broadcasting to the entire South Hill Campus.

In 1968, the college moved the broadcast center to South Hill and later, paid homage to the man who had started the ball rolling decades earlier. In 1976, it was renamed the Michael R. Hanna Broadcast Center, which it remained until its current incarnation as the Roy H. Park Broadcast Center, now housed on the eastern side of the campus, where it has been since 1989.

In 1949, the station signed on to broadcast at 10 watts. In January 1976, the school was granted an upgrade to 5,500 watts. This followed three years of petitioning the FCC for the upgrade.

In 1966, WICB-AM became an affiliate of the Mutual Broadcast radio network, distinguishing it as one of the first college radio stations to have a network affiliation. This relationship lasted until 1969, when both the AM and FM stations joined the ABC Radio Networks.

More recently, MTVu, the nation's most comprehensive television network for college students, recognized WICB-FM as the nation's top college radio station. And as a sign of radio's future, WICB has signed on with Clear Channel Media to be included on its worldwide iHeart Radio internet platform.

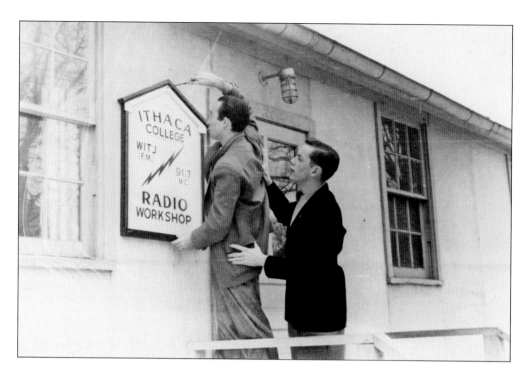

WICB-FM was first known as WITJ. Its home, from the mid-1940s to 1957, was a Quonset hut on Court Street, affectionately called the "radio shack." These photographs are from May 1950 when the shack got a new welcome sign. (Both, courtesy of Park School of Communications, Ithaca College.)

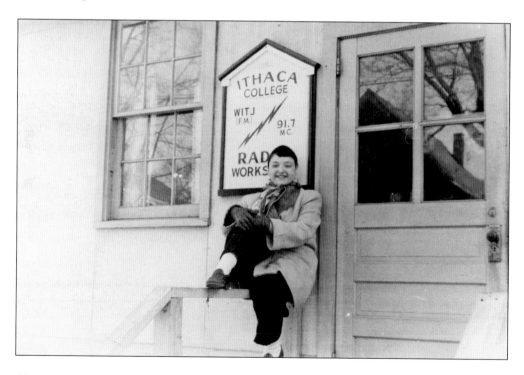

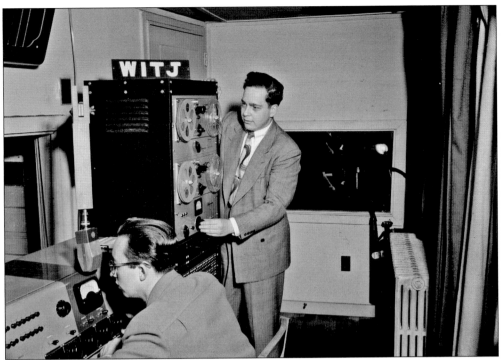

The WITJ-FM control room inside the radio shack is pictured here. This photograph was likely taken in the early 1950s. (Courtesy of Ithaca College Archives.)

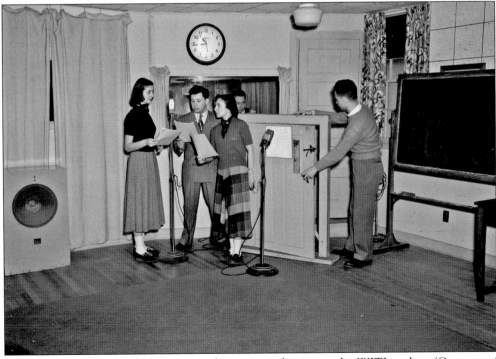

Here, Ithaca College students put on a dramatic production at the WITJ studios. (Courtesy of Ithaca College Archives.)

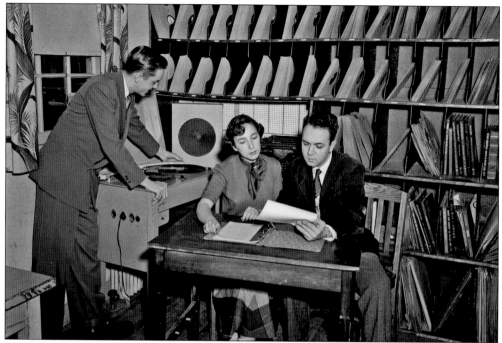

The WITJ record library on Court Street was filled with 16-inch electronic transcription discs and 78-RPM records. (Courtesy of Ithaca College Archives.)

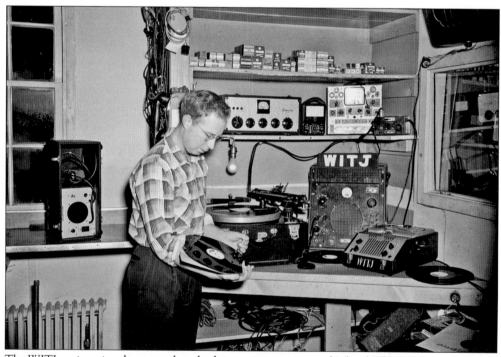

The WITJ engineering shop was where broken equipment went to be fixed. The WITJ sign rests atop a small portable console. The shelves contain test equipment and vacuum tubes, which were used in most electronics during these pre-transistor days. (Courtesy of Ithaca College Archives.)

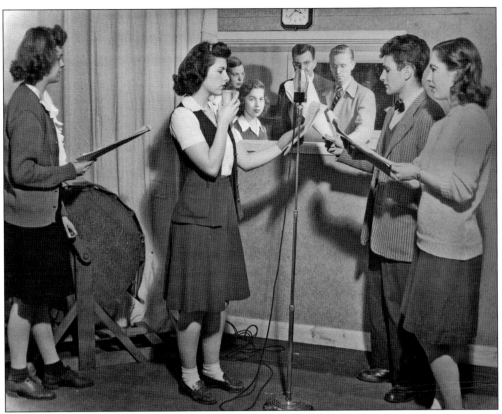

The WITJ Radio Players are pictured doing what they did best: performing a live play on the radio! (Courtesy of Ithaca College Archives.)

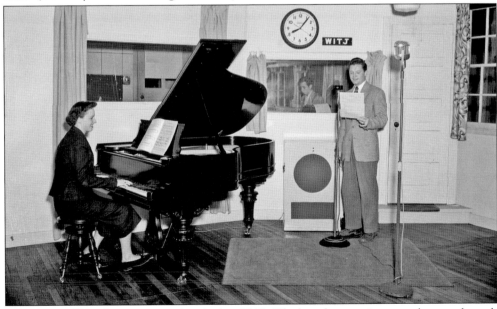

A live musical broadcast is pictured in the late 1940s. The broadcast engineer can be seen through the soundproof glass behind the singer-announcer. (Courtesy of Ithaca College Archives.)

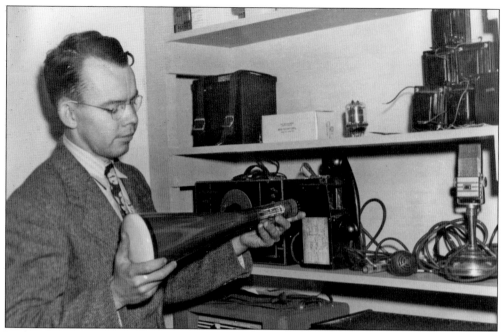

In the WITJ radio shack, in the late 1940s, Ed Pinckney is seen holding a cathode ray tube, today called "CRT" for short. CRTs were used for early television sets, electronic test equipment, and, later, computer displays. (Courtesy of Park School of Communications, Ithaca College.)

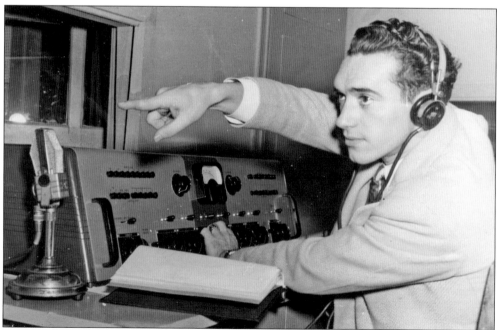

Harry Basch is pictured in the 1940s at WITJ. (Courtesy of Park School of Communications Ithaca College.)

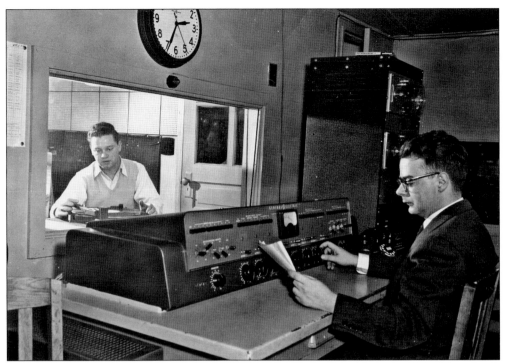

WICB moved its broadcast studios to Buffalo Street in downtown Ithaca in 1957. (Photograph by C. Hadley Smith, Ithaca College.)

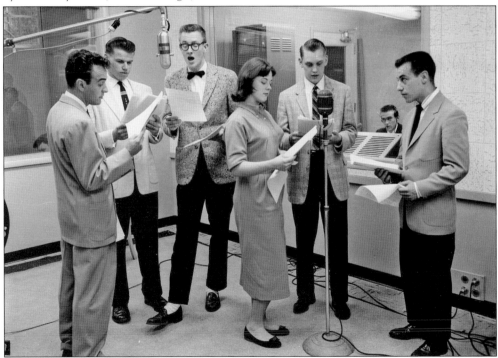

Even as radio turned more to records during the 1950s, WICB continued to broadcast live music programs and plays. (Photograph by C. Hadley Smith, Ithaca College.)

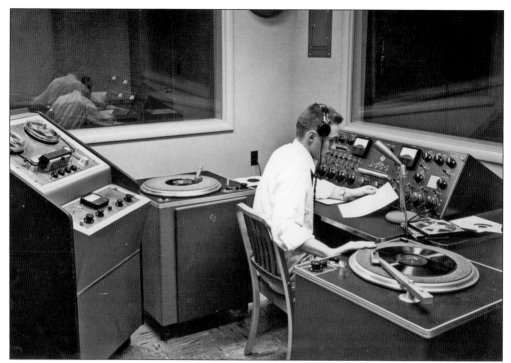

Here, two WICB studios are seen in the 1950s. The turntables have 16-inch platters, once used to broadcast vintage electronic transcription discs. The Ampex reel-to-reel tape deck was used into the late 1970s, after WICB's move to South Hill. (Both, photographs by C. Hadley Smith, Ithaca College.)

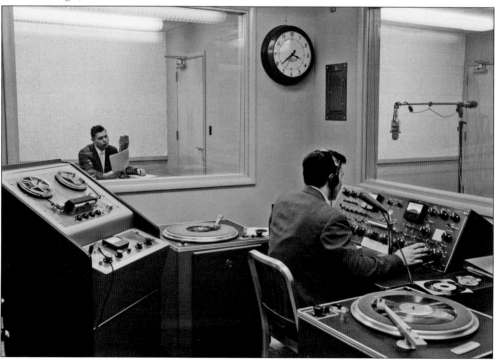

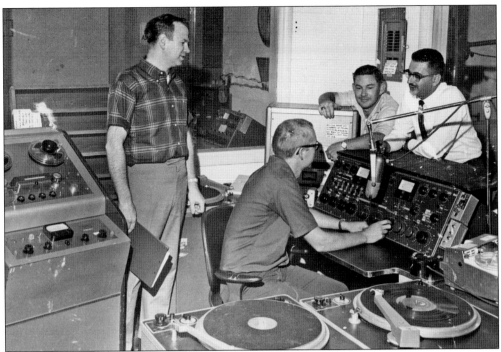

Pictured in the mid-1960s are, from left to right, WHCU's Rudy Paolangeli, Ithaca College professor Bill Harrison (sitting), engineer Dave Allen, and Ithaca College professor and future dean, John Keshishoglou. The control room was equipped with three turntables and two reel-to-reel decks for recorded segments and spots and a classic RCA 77DX microphone, an announcer's dream! One can almost hear these guys saying, "Hey, let's put on a show!" (Courtesy of Ithaca College Archives.)

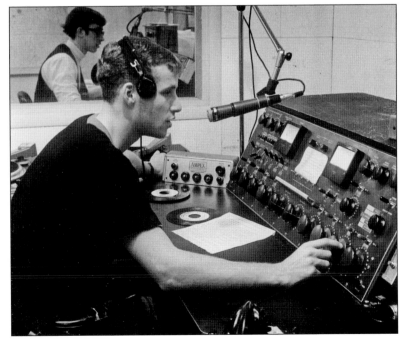

Seen are adjacent WICB studios at the Buffalo Street location in downtown Ithaca in the 1960s. (Courtesy of Ithaca College Archives.)

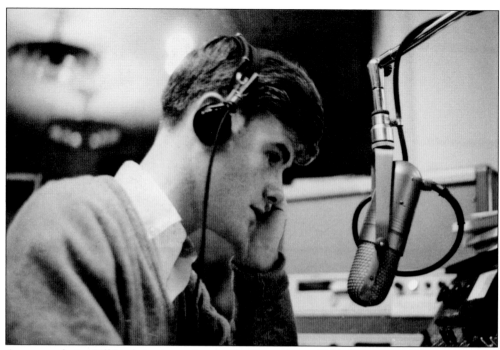

A contemplative Bill Little is pictured at the WICB studio in 1966. (Courtesy of Steve Schwartz.)

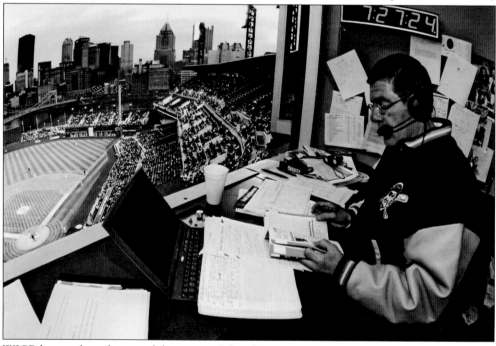

WICB has graduated some of the country's best-known sports announcers. Lanny Frattare was an Ithaca College student from 1966 to 1970 and also worked in Geneva and Rochester while in school. In 1976, he began a 32-year career as the radio-television play-by-play voice of the Pittsburgh Pirates. Frattare is shown preparing for a game broadcast at PNC Park. (Courtesy of Pittsburgh Pirates.)

This is the cover of a WICB-AM weekly music survey from September 30, 1968, featuring disc jockey and future NBC News correspondent Bob Kur. Note that his DJ shift was one day a week—a lot of students angled for airtime! And how about the phrase "Boss Beat?" "Boss" was a term used by many Top 40 stations during the 1960s. (Courtesy of Bob Kur.)

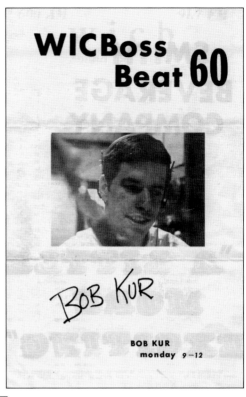

WICBoss Beat 60

Bob Kur

BOB KUR
monday 9—12

600 AM 91.7 FM
w i c b
Sound 60 Survey

Week of September 30, 1968

This Week	Last Week	Title	Artist
1	HB	REVOLUTION/HEY JUDE	BEATLES
2	16	FIRE	ARTHUR BROWN
3	6	THE SNAKE	AL WILSON
4	2	I SAY A LITTLE PRAYER	ARETHA FRANKLIN
5	3	YOU'RE ALL I NEED TO GET BY	GAYE/TERRELL
6	8	I'VE GOTTA GET A MESSAGE TO YOU	BEE GEE'S
7	25	SIX MAN BAND	ASSOCIATION
8	22	TIME HAS COME TODAY	CHAMBER BROTHERS
9	28	GIRL WATCHER	O'KAYSIONS
10	18	THE WEIGHT	JACKIE DeSHANNON
11	30	NATURALLY STONED	AVANTE-GARDE
12	HB	OVER YOU	UNION GAP
13	12	TUESDAY AFTERNOON	MOODY BLUES
14	7	THE HOUSE THAT JACK BUILT	ARETHA FRANKLIN
15	21	SPECIAL OCCASION	SMOKEY ROBINSON
16	14	FOOL ON THE HILL	SERGIO MENDES
17	9	YOU KEEP ME HANGIN' ON	VANILLA FUDGE
18	11	JOURNEY TO THE CENTER OF THE MIND	AMBOY DUKES
19	13	BORN TO BE WILD	STEPPENWOLF
20	HB	SHAPE OF THINGS TO COME	MAX FROST/TROOPERS
21	29	BROWN EYED WOMAN	BILL MEDLEY
22	15	LIGHT MY FIRE	JOSE FELICIANO
23	10	PEOPLE GOTTA BE FREE	RASCALS
24	–	SHAKE	SHADOWS OF KNIGHT
25	4	HUSH	DEEP PURPLE
26	–	MIDNIGHT CONFESSIONS	GRASS ROOTS
27	–	STREET FIGHTIN' MAN	ROLLING STONES
28	HB	WHERE DO I GO	CARLA THOMAS
29	HB	ELENORE	TURTLES
30	17	HELP YOURSELF	TOM JONES
HITBOUNDS			
		I FORGOT TO GIVE HER LOVE	JAMES BROTHERS
		FOR THE LOVE OF IVY	MAMAS AND THE PAPAS
		SUNDAY SUN	NEIL DIAMOND
		SHOOT 'EM UP BABY	ANDY KIM
		HERE I AM BABY	MARVELETTES

THIS LISTING OF RECORDS IS THE OPINION OF WICB-AM BASED ON ITS SURVEY OF
RECORD SALES, LISTENERS' REQUESTS AND WICB*AM'S JUDGEMENT OF A RECORD'S APPE/

This is a WICB-AM music survey for September 30, 1968. Music fans will recognize most of the titles, but a few have left the authors scratching their heads! And yes, WICB-AM really did play Tom Jones and Sergio Mendes side by side with the Beatles, Stones, and Vanilla Fudge because that was what Top 40 did back in the day. (Courtesy of Bob Kur.)

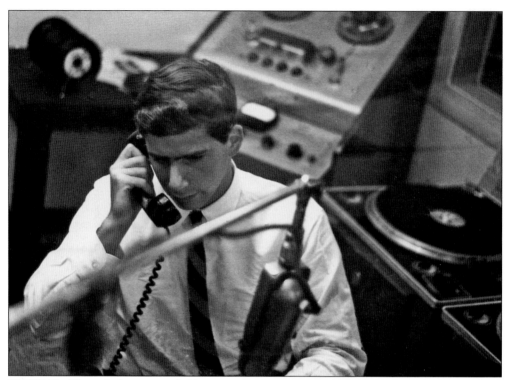

WICB's Fred Eisenthal is surrounded by some classic equipment in 1968. The reel-to-reel tape deck in the background was used at WICB as late as the mid-1970s in the station's audio production room. Eisenthal later became an accomplished television director. (Courtesy of Steve Schwartz.)

Jessica Savitch, pictured here in the late 1960s, was one of the few women disc jockeys on the air at the time. As a student, she worked at WICB and then went on to work professionally for WBBF-AM Rochester as "the Honeybee." Savitch gained fame as a news anchor at KYW-TV Philadelphia during the 1970s before joining NBC News. Savitch died in an automobile crash in 1983 and was the subject of—or inspiration for—several books and films. Ithaca College has memorialized her with a scholarship and other tributes. (Courtesy of Steve Schwartz.)

Here is a look inside the WICB-FM studios on Buffalo Street in 1968. Bob Schulman is reading his copy before going on air. (Courtesy of Steve Schwartz.)

WICB-FM's Dee Adamczyk, pictured in 1967, is in the Buffalo Street studios in downtown Ithaca. A reel-to-reel tape recorder is on the left. A vintage RCA control board and two turntables were standard equipment at the time. (Courtesy of Steve Schwartz.)

Richard Gerdau became a prolific and well-respected long-form television producer at ABC News, where he oversaw major projects such as *The Century*, *The Beatles*, and more. He also worked for many years on ABC's *20/20*. Gerdau died as this book was being written. He is shown here inside the WICB-FM studio. (Courtesy of Steve Schwartz.)

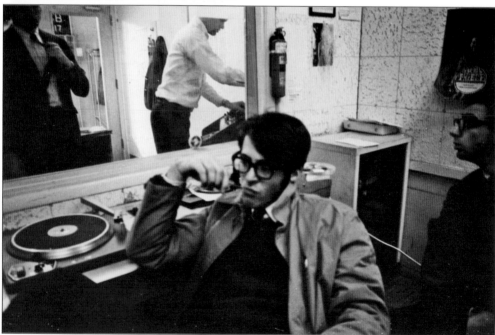

Steve Schwartz, pictured here in the WICB-FM studio in 1967, became what he affectionately calls "a stoop laborer" in television, working on production and development "pretty much everywhere with everybody you've heard of!" In 2013, he was a consultant with the REELZ Channel. (Courtesy of Steve Schwartz.)

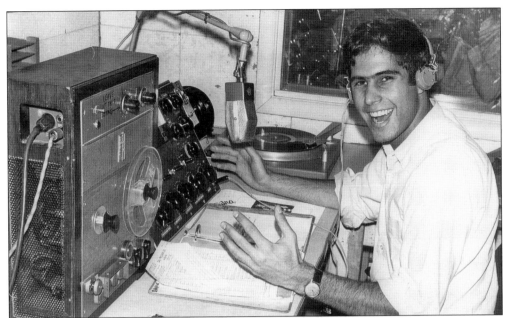

Rich Newberg is at the mic in this late 1960s photograph of the WICB studios. It is possible that no one has ever looked happier to be on the air, but Newberg found his true calling in television news, working in Ithaca, Syracuse, Rochester, and Chicago before settling down in Buffalo, where he has been a fixture at WIVB Channel 4 since 1978. Newberg has won 11 Emmys for his reporting. (Courtesy of Park School of Communications, Ithaca College.)

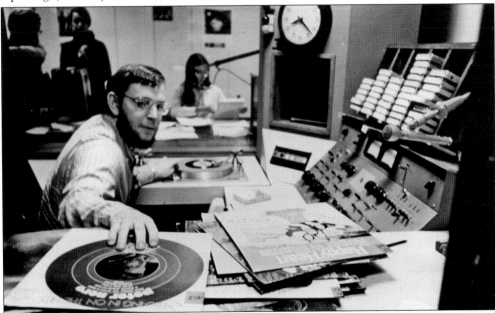

WICB moved from Buffalo Street to the new South Hill Campus, on the ground floor of the Dillingham Center for the Performing Arts, in 1969. This is an off-air student training session. What is remarkable is the music selection. Look at the albums. Pianists Peter Nero and Roger Williams were certainly not staples of college radio in the 1960s! (Photograph by C. Hadley Smith Ithaca College.)

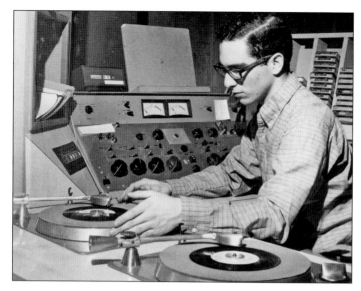

Here, disc jockey–engineer Mike Heiss cues up a record at the state-of-the-art WICB South Hill studios. To the right of the turntable is the remote control for an Ampex reel-to-reel tape deck, which is out of reach and view. To the right of the RCA console is a rack of tape cartridges, which were used for music, jingles, and recorded announcements, with a pair of "cart" machines just below. (Courtesy of Ithaca College Archives.)

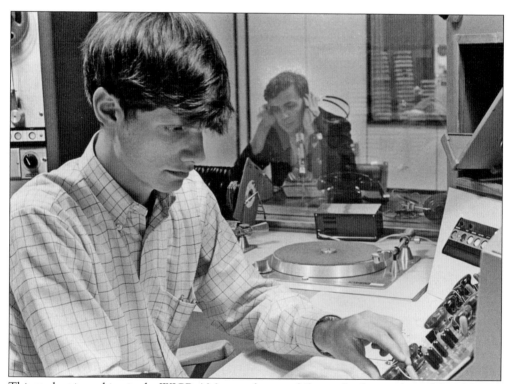

This student is working in the WICB-AM control room while another listens through headphones in the adjacent studio around 1969. The AM and FM studios were identical. WICB-AM broadcast on carrier current through Ithaca College's electrical grid, and later on Cerrache Cable-FM. (Courtesy of Ithaca College Archives.)

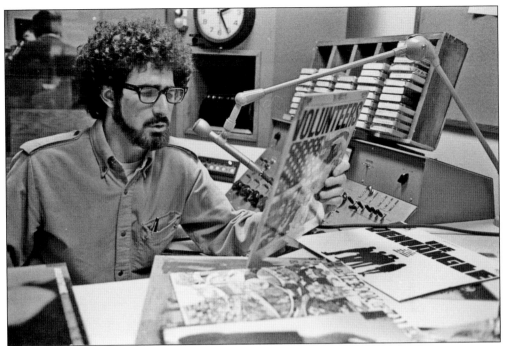

Ithaca College radio played some of the big hits and many not-so-big ones in breaking new music. This disc jockey is holding the cover for Jefferson Airplane's *Volunteers*, a bestselling album as the 1960s turned into the 1970s. Nearby is a much lesser-known record by the British folk rock band The Pentangle. (Photograph by Robert Bonnell, Ithaca College.)

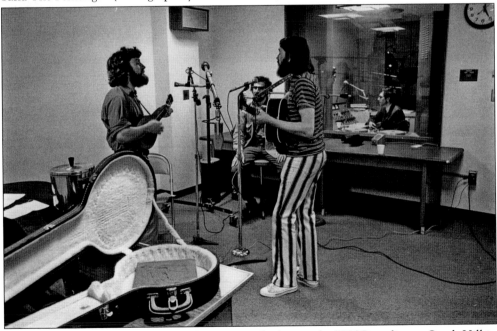

Is it live? Or is it Memorex? This performance took place at the WICB studios on South Hill in 1969. These were pretty spacious digs, with the control room just on the other side of the glass. (Courtesy of Ithaca College Archives.)

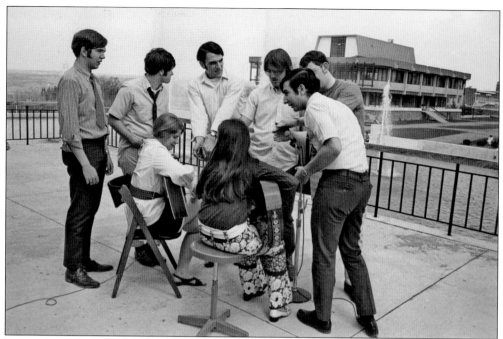

Here, a WICB remote broadcast is taking place next to the fountains at the Dillingham Center on the South Hill Campus. This patio was located just upstairs from the studios; this broadcast required hundreds of feet of microphone cable, snaked through doors and along hallways, to bring the signal to the control room and to radio listeners. (Courtesy of Ithaca College Archives.)

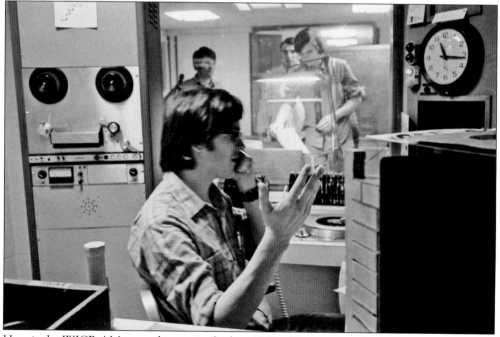

Here is the WICB-AM control room in the late 1960s. (Courtesy of Ithaca College Archives.)

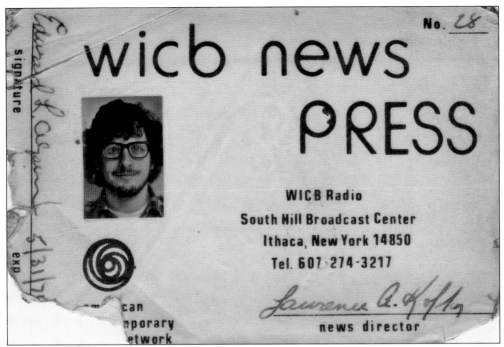

This is a 1974 WICB News press pass. It belonged to Ed Alpern, who later became a respected television news producer for CBS and is now a self-employed video producer. The card is signed by WICB's news director Larry Kofsky, who now covers Wall Street for MarketWatch.com and is heard on stations like 1010-WINS New York. (Courtesy of Edward Alpern.)

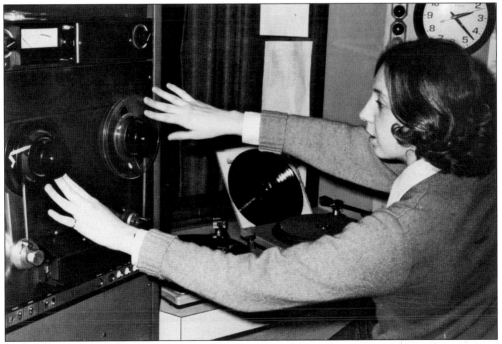

Here, WICB news anchor and reporter Pat Higgins cues a reel-to-reel tape for airplay in one of the WICB studios around 1974. (Courtesy of Park School of Communications Ithaca College.)

```
AAAAAAAAAAAAAAAAAAAAAAAAAAAAAAAAAAAAAAAAAAAAAAAAAAAAAAAAAAAAAA

  1>>THE NEED TO BE              JIM WEATHERLY      06  OCC 3:55
  2>>LOVE DON'T LOVE NOBODY      SPINNERS           46  OCF 3:33
  3>>LONGFELLOW SERENADE         NEIL DIAMOND       09  OCF 3:22
  4>>PEOPLE GOTTA MOVE           GINO VANNELLI      10  OCF 3:18
  5>>WHEN WILL I SEE YOU AGAIN   THREE DEGREES      18  OCF 2:58
  6>>SO YOU ARE A STAR          HUDSON BROTHERS     C   OCC 2:45
  7>>ROCKIN' SOUL               HUES CORP.          10  OCF 2:59
  8>>I CAN HELP                 BILLY SWAN          19  27C 2:57
  9>>WISHING YOU WERE HERE       CHICAGO            36  OCC 4:28
 10>>SHA LA LA (MAKE ME HAPPY)   AL GREEN           18  OCF 2:56
 11>>ANGIE BABY                 HELEN REDDY         06  OCF 3:22
 12>>CAT'S IN THE CRADLE         HARRY CHAPIN       12  12F 3:44
 13>>LA LA PEACE SONG            AL WILSON          05  OCF 3:15
 14>>KUNG FU FIGHTING            CARL DOUGLAS       20  OCF 3:08
 15>>EVERLASTING LOVE            CARL CARLTON       12  OCF 2:20
```

These were the top 15 songs on WICB-FM for the week of November 11, 1974, which was the week author Peter King Steinhaus went on the air for the first time as a disc jockey. To the right of the artists' names are the songs' intro times and total length. The computer printout was prepared by assistant program director Glenn Potkowa and generated by the station's in-house computer genius Mark Nechoda on Ithaca College's Univac. (Courtesy of Glenn Potkowa.)

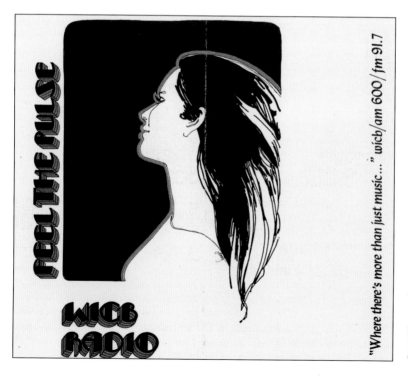

This is a 1974 WICB promotional card. (Courtesy of Glenn Potkowa.)

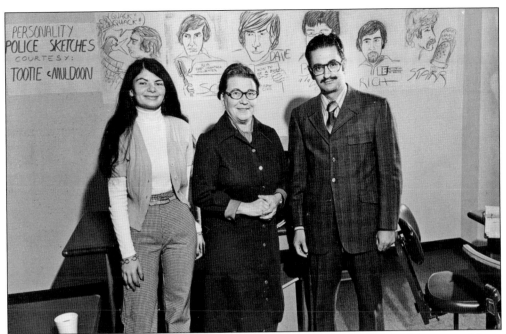

Pictured around 1974 from left to right are WICB *Newsmakers* host Sharon Messenger, Ithaca assemblywoman Constance Cook, and Ithaca College School of Communications dean John Keshishoglou. "Dr. Kesh" led the school through a major growth period in the 1960s and 1970s, and the college's Center for Global Communications Initiative is named in his honor. Messenger is now known as Sharon Schultz and owns a public relations firm in the Washington, DC, area. Behind them are a series of caricatures of the WICB air staff. (Courtesy of Park School of Communications, Ithaca College.)

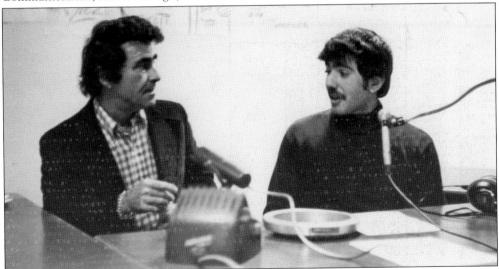

Rod Serling, who led us into the *Twilight Zone* on television, had a home near Ithaca and was a longtime friend of Ithaca College and WICB radio. He recorded station identifications and promos, and taught at Ithaca College until his death in 1975. Students loved him, and he loved them back. He is seen being interviewed by WICB general manager Roger Chiocchi in 1974. (Courtesy of Park School of Communications, Ithaca College.)

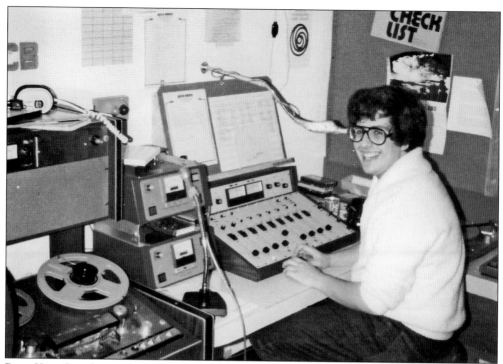

Peter King Steinhaus is hosting his last WICB-FM show on a May 1976 Saturday morning. By then, he was on the air at WTKO-AM, where he would broadcast nightly for two years. King's career took him to Burlington, Vermont, and Syracuse and Rochester, New York, and finally to Orlando, where he is a correspondent for CBS News Radio. This was the new WICB-FM studio, inaugurated after the power increase. (Courtesy of Peter King Steinhaus.)

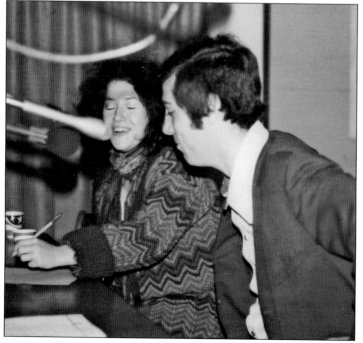

WICB-AM and -FM would annually simulcast a 50-hour marathon to raise money for charitable causes. One student host stayed awake for the entire 50 hour broadcast, which included all staff and guests from the community and, sometimes, celebrities! This 1976 photograph shows singer Melissa Manchester being interviewed by Frank Carpano, who later became the lead sports anchor at WJAR-TV Providence, Rhode Island. (Courtesy of Cindy Smith.)

WICB's Randy Riley is on the air during the fall of 1976. The power boost brought new format rules to what was renamed WICB-Stereo 92 "The Source," and "The Radio Station." Check out the notes just above the control board. Disc jockeys loved to play their favorites, but some songs were overplayed and temporarily banned, as seen on this "no play list." And, as with professional radio stations, it was WICB's program director Steve Goldstein's prerogative to choose which cuts should air, even on hot albums like Boz Scaggs's *Silk Degrees*. (Courtesy of Park School of Communications, Ithaca College.)

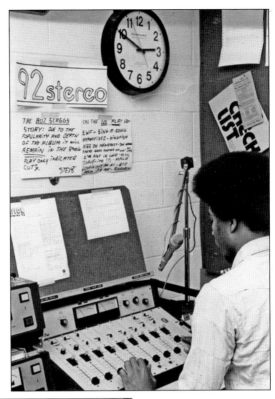

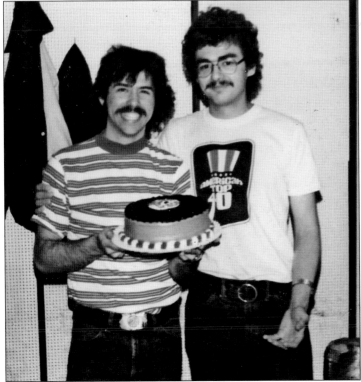

In the 1970s, the hair was big, and so were the mustaches! In 1975–1976, Gary B. Duglin (left) was the producer of WICB's *Recollections* oldies show on Sunday nights. Host Chuck Sivertsen (right) was then known as "Chuck Reynolds" on WICB and WTKO. Duglin later hosted a nationally syndicated show, *Talk with the Stars*. Sivertsen is heard nationally as a correspondent for ABC News Radio. *Recollections* followed *American Top 40* on WICB-FM. (Courtesy of Cindy Smith.)

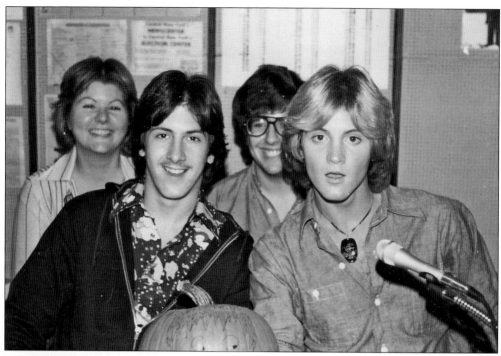

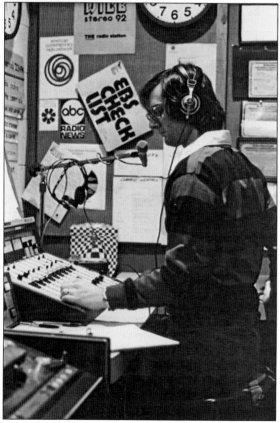

Apparently, everyone in this picture knew they were being photographed except WICB's 1976–1977 *Recollections* host Hank Tenney, on the right in the first row. To his right is show volunteer Jeff Fishman; in the second row are show producer Cindy Thomason, who kept everything on track, and Peter King Steinhaus, who engineered for Tenney after hosting his own *Reflections* oldies show on WTKO. (Courtesy of Cindy Smith.)

Steve Goldstein was WICB's program director from 1976 to 1978. Goldstein developed a solid album rock format and branding that took WICB-FM's 5,500 watts to new heights. WICB was known as "The Radio Station" and "The Source," which Goldstein later developed into a format for NBC Radio. After stops at legendary stations in New York, Hartford, and Detroit, Goldstein became the executive vice president for programming at Saga Communications, where he oversees properties in 23 markets, including Ithaca. (Courtesy of Steve Goldstein.)

With WICB-FM's power boost to 5,500 watts in 1976 came new rules and equipment. Gone was the small 10-watt "mono" transmitter, and arriving were new transmitter controls to be monitored and readings to be logged, along with monitors for WICB's brand-new stereo signal. Disc jockey Randy Riley is shown taking—and logging—FCC-required meter readings. In 1976, the studios were christened as the Hanna Broadcast Center for station benefactor Michael Hanna. (Courtesy of Park School of Communications Ithaca College.)

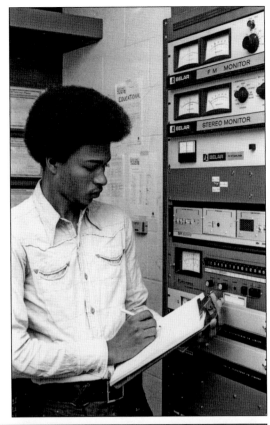

WICB's power increase from 10 to 5,500 watts also meant the construction of a new transmitting tower, located behind the Terrace dorms at Ithaca College. (Courtesy of Dave Allen.)

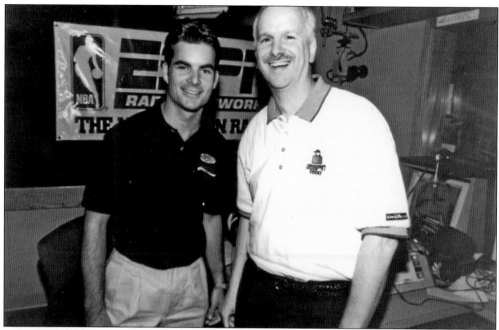

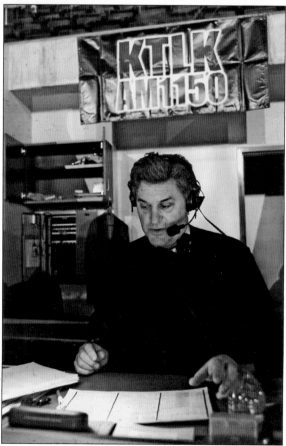

Chuck Wilson (right) is one of many nationally known sportscasters to start at WICB during the 1970s. He spent nearly two decades as an ESPN Radio host; he is pictured here in 1996 with NASCAR legend Jeff Gordon. Wilson now runs a nonprofit organization that promotes good sportsmanship for youth. (Photograph by John Atashian; courtesy of ESPN.)

WICB alum Nick Nickson has called Los Angeles Kings hockey games on the radio for more than three decades. The Staples Center broadcast booth area has been named in his honor. Nickson was WICB's sports director during the early and mid-1970s, calling Ithaca College football, baseball, hockey, and basketball. He is shown here during the Kings' 2013-2014 Stanley Cup championship season. (Courtesy of Los Angeles Kings.)

Miami Heat television play-by-play voice Eric Reid cut his teeth doing sports at WICB during the late 1970s, calling Ithaca College football and basketball games and anchoring sportscasts. Reid is an Emmy winner and the lone remaining voice from the original Heat telecasting team. Check out that impressive NBA Championship ring! (Courtesy of Miami Heat.)

Daria Malinchak was part of WICB-FM's dynamic Saturday night lineup of *Sack and 'Chak* in 1976–1977, holding down the 10:00 p.m.–2:00 a.m. shift widely listened to by late-night partiers. ("Sack" was DJ Scott Lancey's nickname.) She also worked professionally at WHCU and WTKO. She is shown here pulling music for her show from WICB's huge record library. (Courtesy of Park School of Communications, Ithaca College.)

This WICB-FM bumper sticker from around 1976 was robin's egg blue. (Courtesy of Glenn Potkowa.)

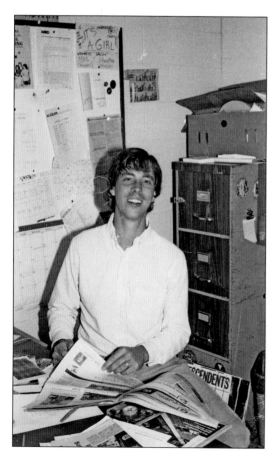

WICB station manager Chris Wheatley is pictured in 1986. Students have come and students have gone, but well into the 2000s, the 1981 Ithaca College grad is still there to keep the i's dotted and the t's crossed. (Courtesy of Brother Mike Cohen.)

WICB's record library was legendary for vinyl of all ages during the 1970s and 1980s. Pictured here is disc jockey Danny Devitto, who later changed his name to "Danny Vermont" to avoid confusion with the actor who shares his legal name. Vermont has performed standup comedy and has written for Bill Maher, George Lopez, and Wanda Sykes. He has been nominated for seven primetime Emmys for *Real Time with Bill Maher* and *Politically Incorrect*. (Courtesy of Brother Mike Cohen.)

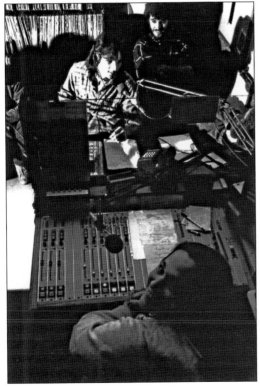

By 1987, WICB's control room had been reconfigured and had grown. It was easily able to accommodate disc jockeys and guests, such as the band Bullfrog Light Company. (Courtesy of Brother Mike Cohen.)

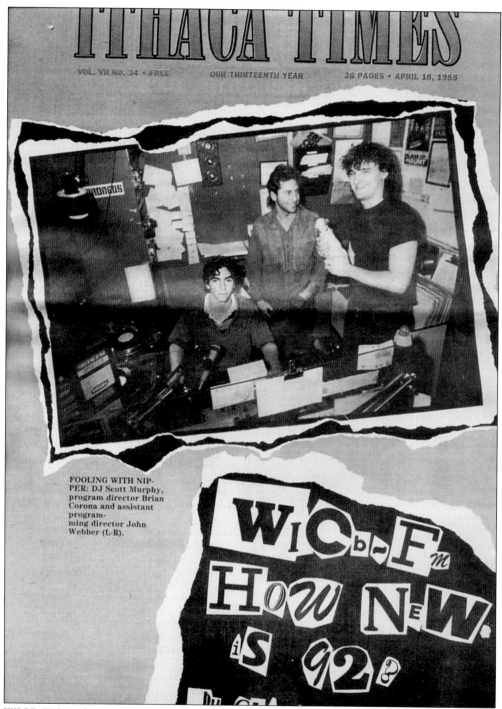

FOOLING WITH NIP-
PER: DJ Scott Murphy,
program director Brian
Corona and assistant
program-
ming director John
Webber (L-R).

WICB-FM made the cover of the *Ithaca Times*, formerly known as the *New Times*, in 1985. (Courtesy of Brother Mike Cohen and the *Ithaca Times*.)

Three

WVBR

In 1935, Cornell University students who were already producing content that aired on WESG formed the Cornell Radio Guild. The call letters ESG stood for the *Elmira Star Gazette* newspaper. The guild members' content contribution had been taking place for three years when the guild decided to incorporate in 1941 and start its own radio station.

The guild has been an independent, nonprofit media organization in Tompkins County, staffed by a blend of students and nonstudent volunteers. Despite the VBR slogan of "Voice of the Big Red," the station has remained unaffiliated with the university since inception, although it has covered Cornell news and sports thoroughly since its beginnings.

The organization went on to provide carrier current broadcasts to the Cornell dormitories in the early 1940s. Broadcasts were mostly classical music back then and remained so as WVBR signed on the FM dial officially in 1958.

A decade later, WVBR abandoned classical music for the FM revolution, featuring pop music and rock. By the mid-1970s, WVBR became more progressive in its rock selection.

The station broadcast from its college-town location on Linden Avenue until 2000, when the station was forced to move to Mitchell Street due to a structural citation from the department of buildings.

In 2012, distinguished Cornell grad and WVBR alum Keith Olbermann made a substantial grant to WVBR to build a brand-new facility, which opened its doors in 2014. The new facility is named the Olbermann-Corneliess Broadcast Center, named in memory of Keith's father and the late VBR alum Glenn Corneliess.

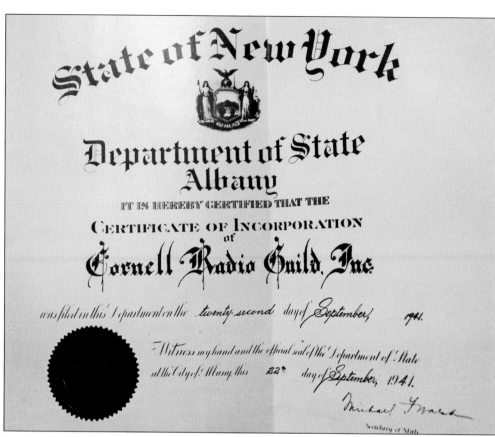

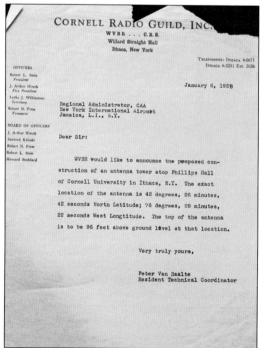

WVBR-FM has been on the air since June 1958, but student-run radio at Cornell began in 1935, when the Cornell Radio Guild began producing programs for university-owned WESG. This is the official incorporation certificate for the guild, from September 22, 1941. Shortly thereafter, the guild founded carrier current WVBR 640 AM, which broadcast on campus. (Courtesy of Cornell University Division of Rare and Manuscript Collections.)

WVBR had long been a carrier current AM station, broadcasting at 640 on the dial through Cornell's electrical grid, but in June 1958, WVBR-FM went on the air at 93.5 MHz. This letter to the Civil Aviation Authority (predecessor to the FAA) details plans for the station's new transmitting tower. (Courtesy of Cornell University Division of Rare and Manuscript Collections.)

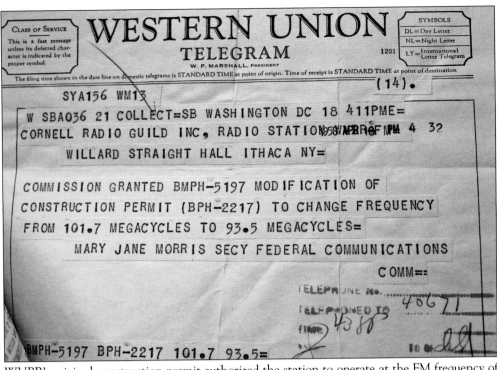

WVBR's original construction permit authorized the station to operate at the FM frequency of 101.7 MHz. But before the station signed on in June 1958, the FCC approved a change to a more desirable frequency of 93.5. This is the FCC's telegram to the Cornell Radio Guild. (Courtesy of Cornell University Division of Rare and Manuscript Collections.)

In case you haven't heard . . .

THERE'S A NEW RADIO STATION IN TOWN

WVBR - FM

93.5 mc

Serving the Southern

Finger Lakes Region

"ITHACA'S HI-FI VARIETY STATION"

DAILY PROGRAMS

12:00 Noon	Instrumental Mood Music
4:00 P.M.	Popular Music
5:45	World and Money Area News
6:00	Music for Cocktails and Dining
7:00	Jazz
8:00	Evening Concert of Classical Music
11:00	World News In Depth
11:30	Instrumental Mood Music

SPECIAL WEEKEND PROGRAMS

Saturday
7- 8 P.M. Broadway Show
8- 1 Dancing Party

Sunday
11-12 A.M. Sage Chapel Service
2- 3 P.M. Opera Performance
7- 8 Cornell University Lecture Series

WVBR-FM's early programming provided a mixture of several kinds of music, along with news, lectures, and religious programming. This ad is likely from June 1958, just after the station signed on for the first time. (Courtesy of Cornell University Division of Rare and Manuscript Collections.)

WVBR AND WVBR-FM

640 kcs. 93.5 mcs.

Offers Freshmen experience in

- ## BUSINESS
 - ## PROGRAMMING
 - ## ENGINEERING

SIGN-UP AT THE ACTIVITIES FAIR
or
AT THE STUDIOS IN THE STRAIGHT

Remember: Listen to WVBR and WVBR-FM
640 on your AM dial and 93.5 FM

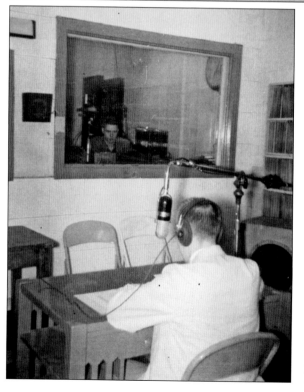

With an already established carrier current AM station and a fledgling FM signal, WVBR needed people to run both stations. This recruitment ad appeared in the *Cornell Daily Sun* during the fall of 1958. (Courtesy of Cornell University Division of Rare and Manuscript Collections.)

WVBR has had several homes, but its first broadcast studios, seen here in 1957, were in Willard Straight Hall on Cornell's campus. (Courtesy of Cornell University Division of Rare and Manuscript Collections.)

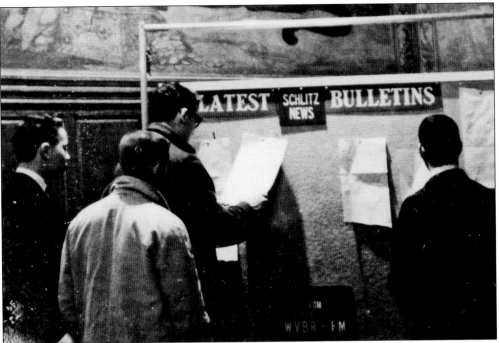

In 1961, WVBR posted news headlines periodically outside its Willard Straight Hall studios so students, faculty, and staff could keep up to date during pre-internet, pre-cable days. (Courtesy of Cornell University Division of Rare and Manuscript Collections.)

WVBR's *Music After 7* was heard during the station's classical era, from the late 1950s through the early to mid-1960s. This display is inside Fred's Record Shop on State Street in downtown Ithaca. (Courtesy of Cornell University Division of Rare and Manuscript Collections.)

During its classical music era, WVBR issued program guides to tell listeners what music it would play and when. These are some of the more artistic covers from the early 1960s. (Both, courtesy of Cornell University Division of Rare and Manuscript Collections.)

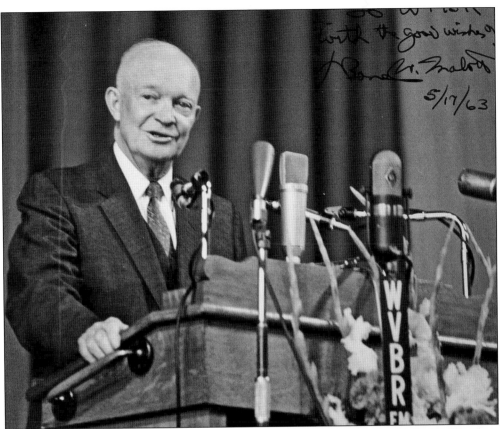

Former president Dwight Eisenhower is seen visiting the "White House"—Cornell's Andrew D. White House—where he was the guest of honor at a luncheon on May 17, 1963. The luncheon was covered by WVBR and hosted by Eisenhower's friend, Cornell president Deane W. Malott, who signed this photograph. Both men grew up in Abilene, Kansas. (Courtesy of Cornell University Division of Rare and Manuscript Collections.)

Someone has to make sure that commercials are scheduled and that they run as promised. In 1963, during WVBR's classical and jazz music era, traffic manager Don Stone was that person. (Courtesy of Cornell University Division of Rare and Manuscript Collections.)

By the mid-1960s, WVBR had dropped classical music for contemporary hits. Charles Schulz probably never got a dime when WVBR used Charlie Brown on these two sweatshirts. The 1966 "Bad Guys" shirt may have been a take-off on WMCA-New York's "Good Guys." The "WVBR Music Man" shirt is from 1968. Bill Dugatkin is credited as the artist. (Both, courtesy of Cornell University Division of Rare and Manuscript Collections.)

This is WVBR's Studio B in Willard Straight Hall in 1967. (Courtesy of Cornell University Division of Rare and Manuscript Collections.)

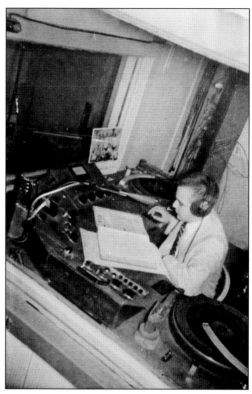

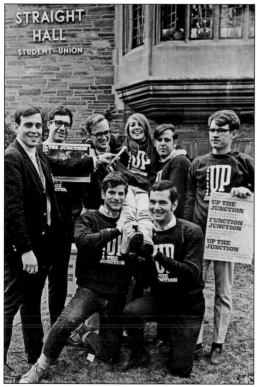

A WVBR promotion for the premiere of the British film *Up the Junction* is pictured in 1968. This was billed as the first "sweatshirt premiere;" only those wearing the sweatshirts would be admitted to the screening. (Courtesy of Cornell University Division of Rare and Manuscript Collections.)

A WVBR remote broadcast from a station-sponsored picnic is pictured in the late 1960s. (Courtesy of Cornell University Division of Rare and Manuscript Collections.)

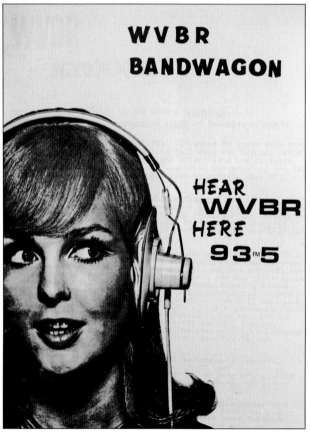

WVBR has always been owned and operated by the student-run Cornell Radio Guild as a commercial enterprise. This is the cover of a 1968 sales presentation. (Courtesy of Cornell University Division of Rare and Manuscript Collections.)

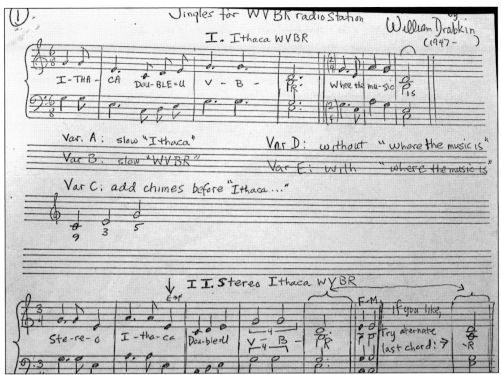

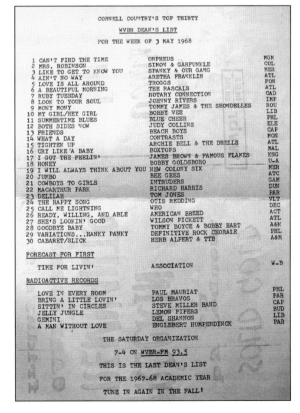

WVBR went through several format changes. It played Top 40 and CHR (contemporary hit radio) music during parts of the 1960s and 1980s. This sheet music is from a WVBR jingle from the late 1960s. (Courtesy of Cornell University Division of Rare and Manuscript Collections.)

WVBR played the hits during the late 1960s, when Top 40 radio meant listeners could hear Englebert Humperdinck, Herb Alpert, and Tom Jones in the same sets as James Brown, Aretha Franklin, and the Who. Take a good look at WVBR "Dean's List" for May 3, 1968. (Courtesy of Cornell University Division of Rare and Manuscript Collections.)

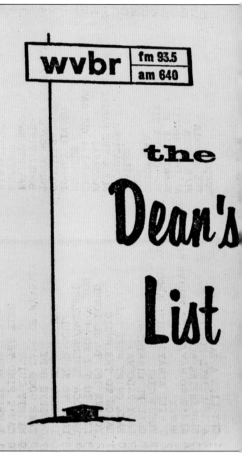

SOLID GOLD

by request
on

ROCKIN'
REMNANTS
with
GARY FISHER
TRADEMARK

fridays 9-2

wvbr | fm 93.5 | am 640

the
Dean's
List

WVBR's *Rockin' Remnants* oldies show began in the early 1960s, when it was broadcast on WVBR-AM 640. WVBR.com suggests the FM version debuted in 1972, although this flyer mentions the Dean's List, which was a part of the WVBR of the late 1960s. *Remnants* was on and off the air sporadically until 1981, when it returned for good. (Courtesy of Cornell University Division of Rare and Manuscript Collections.)

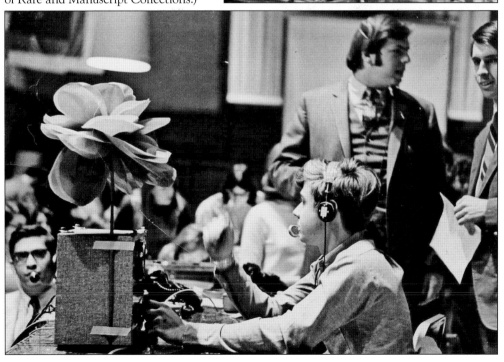

WVBR has produced many nationally known broadcast journalists, including Bettina Gregory (ABC), Mark Smith and Brad Kalbfeld (AP Radio), Kate Snow (NBC), and Pam Coulter (ABC and CBS News). They cut their teeth covering big events, including elections. These election night pictures from November 1968 feature WVBR news director Gary Kaye, who became a respected technical journalist. (Both, courtesy of Cornell University Division of Rare and Manuscript Collections.)

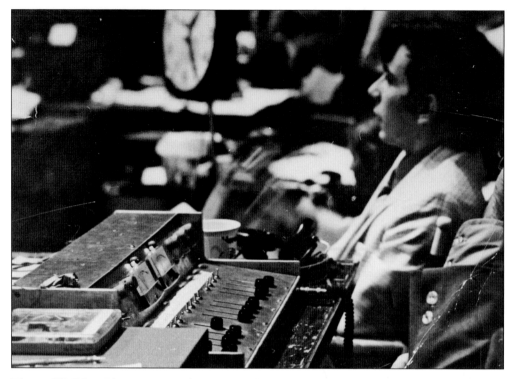

This is WVBR's "Election Central" in November 1970. Below are, from left to right, Harriet Edwards, John Watibeine, J.J. Regan (who later became the morning host, program director, and station manager for WTKO), and J. Thomas Marchitto. (Courtesy of Cornell University Division of Rare and Manuscript Collections.)

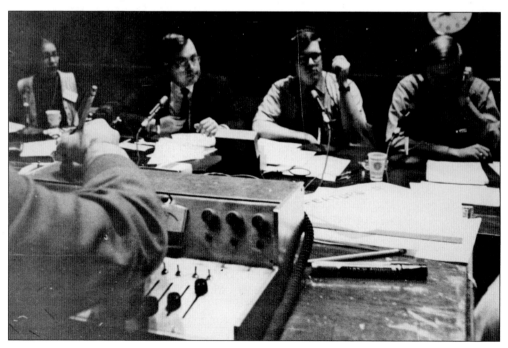

This WVBR news script comes from one of the most turbulent weeks in Cornell's history. About 40 African American students took over Willard Straight Hall for 36 hours on April 19, 1969. They were protesting perceived racism, Cornell's apparent slowness at establishing a black studies program, and a judicial system they felt was unfair to black students. (Courtesy of Cornell University Division of Rare and Manuscript Collections.)

WVBR NEWS: Henrhan

11:45 AM

WVBR NETWORK TAG NEWS

At last report, [illegible] black students still retain control of Cornell U.'s student union bldg. (WSH). The group entered shortly afterr 6:00 this morn. demanding that a recent decision of a Cornell judiciary board (which reprimanded 2 black students) be declared null and void and that amnesty be granted for all of the protestes inside the bldg.

At least one scuffle has broken out between white and blacks inside the student union bldg.; both sides have charged each other with using weapons (including 2x2 planks and acid).

Cornell Pres. Perkins has called the seizure "an astonishing and regrettable action".

Most Parents Weekend activities will continue. Parents should contact the Noyes Cen. Desk (275-4722) for program changes...

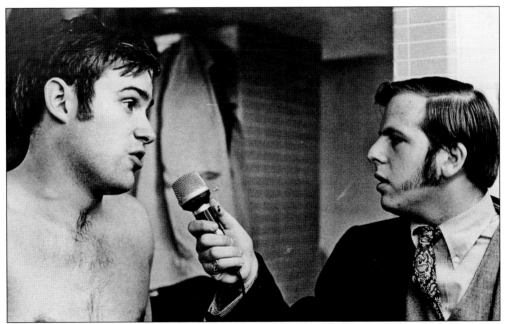

WVBR news director Gary Kaye is with Cornell goalie Ken Dryden after the Big Red won the Eastern College Athletic Conference (ECAC) hockey championship at the Boston Garden in 1969. Dryden went on to become a Hall of Famer with the NHL's Montreal Canadiens. Gary Kaye became a technical journalist with stints at NBC, ABC, CNN, and Fox. He founded intheboombox.tv, which covers technology as it pertains to baby boomers. (Courtesy of Cornell University Division of Rare and Manuscript Collections.)

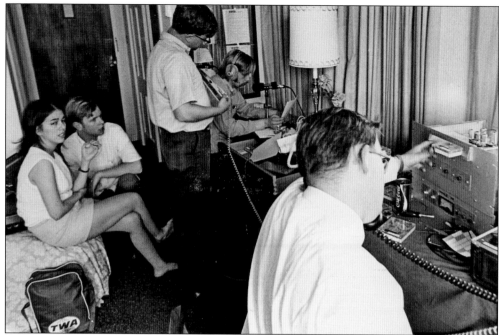

On May 9, 1970, WVBR went to Washington to cover a huge student demonstration against the Kent State shootings and the Vietnam War. Its reporters anchored coverage for a national network of college radio stations from the Washington Hotel. From left to right are Stella Petrakis, John Henrehan, Ned Fisher, J. Thomas Marchitto (at the mic), and John Matilaine at the console. (Courtesy of Cornell University Division of Rare and Manuscript Collections.)

227 Linden Avenue was WVBR's home from the late 1960s through 2000. This is how the building looked in 2013. (Photograph by Chris Wheatley.)

As the 1970s arrived, WVBR joined the FM revolution and began playing more progressive, album-oriented music. This WVBR ad from the early 1970s is one of perhaps hundreds that have appeared in the *Ithaca New Times*, now known as the *Ithaca Times*. (Courtesy of David Dy Tang and *Ithaca Times*.)

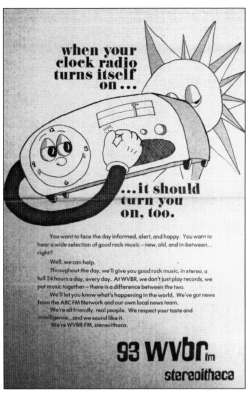

when your clock radio turns itself on ...

...it should turn you on, too.

You want to face the day informed, alert, and happy. You want to hear a wide selection of good rock music – new, old, and in-between... right?

Well, we can help.

Throughout the day, we'll give you good rock music, in stereo, a full 24 hours a day, every day. At WVBR, we don't just play records, we put music together – there is a difference between the two.

We'll let you know what's happening in the world. We've got news from the ABC FM Network and our own local news team.

We're all friendly, real people. We respect your taste and intelligence...and we sound like it.

We're WVBR-FM, stereoithaca.

93 wvbr fm
stereoithaca

This early 1970s cartoon was likely created for WVBR staff members, as there are many "inside" references that the general public might not understand. (Courtesy of Cornell University Division of Rare and Manuscript Collections.)

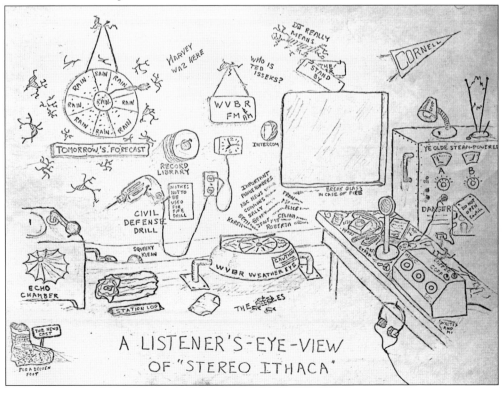

A LISTENER'S-EYE-VIEW OF "STEREO ITHACA"

SIAMESE TWINS, JOINED AT THE EGO

This WVBR yearbook photograph shows sports director Keith Olbermann (left) and program director Glenn Corneliess. Corneliess's career on and off the air included radio station management and an executive position with Katz Radio, where, according to Olbermann, he was one of the company's "wise young men" who taught new recruits "how to do radio correctly." Olbermann's sizable financial contribution helped WVBR move into a new state-of-the-art facility, which is named for his late father, Theodore, and Corneliess, who died in 1996 at age 39. (Courtesy of Keith Olbermann.)

Staffer Stacey Cahn of WVBR best remembers program director Glenn Corneliess as he looked in this late 1970s photograph. (Courtesy of Stacey Cahn.)

This WVBR yearbook photograph has an inscription to Keith Olbermann from Carol Hebb. Hebb later worked in radio news at UPI and ABC, and despite the inscription, Hebb and Olbermann were never married in real life. (Courtesy of Keith Olbermann.)

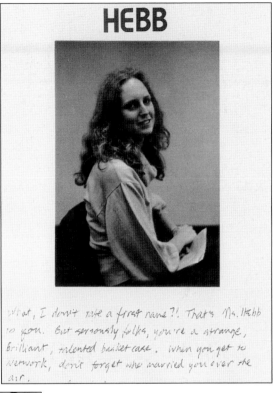

HEBB

What, I don't rate a first name?!. That's Ms. Hebb to you. But seriously folks, you're a strange, brilliant, talented basket case. When you get to network, don't forget who married you over the air.

Pam Coulter and Peter Susser are shown in the WVBR newsroom. Coulter later worked at WTOP Washington and then CBS News Radio before spending 12 years as a correspondent for ABC News Radio. After a brief stop at NPR, she returned to CBS Radio in 2010 as a correspondent in Washington, DC. Susser is an attorney in the DC area. (Courtesy of Pam Coulter.)

This photograph, likely from 1977, shows WVBR reporter-anchor Stacey Cahn, with the then-popular Dorothy Hamill hairstyle. Cahn later worked for WTKO and two Long Island stations. Her career took her to WNEW-FM in New York and then to NBC Radio and The Source. As a writer-producer, she helped launch CNBC and Fox News Channel. Cahn now lives in Florida, where she owns Time in a Bottle Video Productions. (Courtesy of Stacey Cahn.)

WVBR's sports director during the mid-to-late 1970s was Keith Olbermann; he went on to make his mark in both sports and news. Olbermann's long broadcast resume includes UPI, RKO, and WNEW Radio, KTLA and KCBS-TV in Los Angeles, CNN, ESPN (*SportsCenter*), Fox Sports, NBC, MSNBC (*Countdown with Keith Olbermann*), and Current TV. He has also written extensively about his passion, baseball, for several websites. In 2013, Olbermann returned to ESPN for a late-night show that bears his name and followed his passion by anchoring TNT's postseason Major League Baseball telecasts. (Courtesy of Peter Schacknow.)

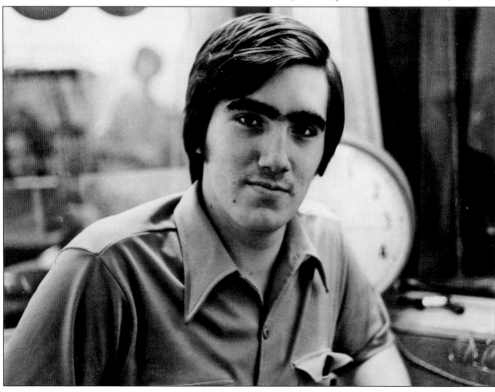

WVBR program director Glenn Corneliess (left) and news director Peter Schacknow are pictured in the 1970s. Corneliess's long career as a radio programmer took him to many stations, and finally to Katz Radio. Corneliess died suddenly in 1996, and WVBR's new broadcast facility bears his name. Schacknow's career in journalism includes stops at CBS, ABC, UPI, and Bloomberg Radio. He was a founding staffer at CNBC, and in his second stint there, he is a senior producer. (Courtesy of Peter Schacknow.)

Here, Peter Schacknow is delivering a newscast during a late 1970s snowstorm. He says that on this particular day, he looks disheveled because, with many roads shut down, he had to park downtown and walk up the steep hill to the WVBR studios in Collegetown. (Courtesy of Peter Schacknow.)

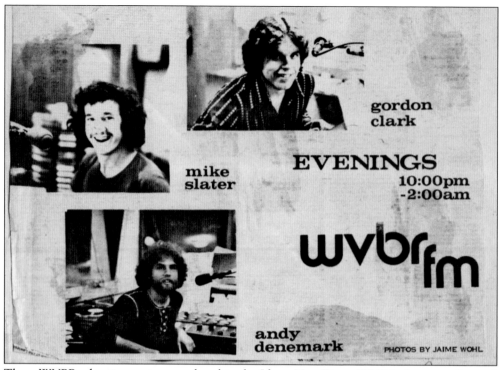

These WVBR advertisements were placed in the *Ithaca New Times*. WVBR air personality and *Nonesuch* host Jaime Wohl created them for an advertising course at Ithaca College during the mid-1970s. (Both, courtesy of Jaime Wohl.)

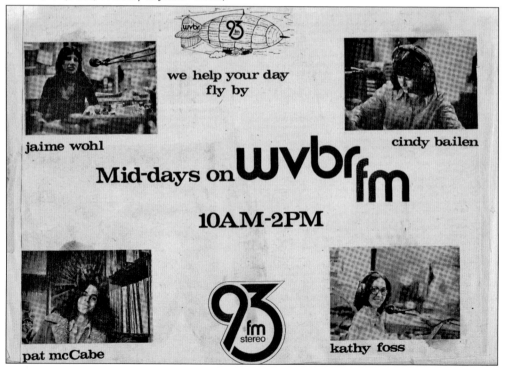

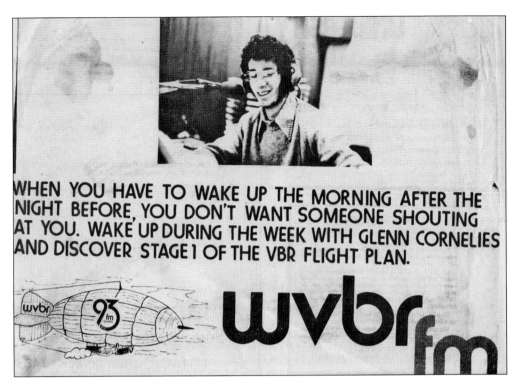

Wohl says that she earned an A for her work, which featured her fellow WVBR air personalities. (Both, courtesy of Jaime Wohl.)

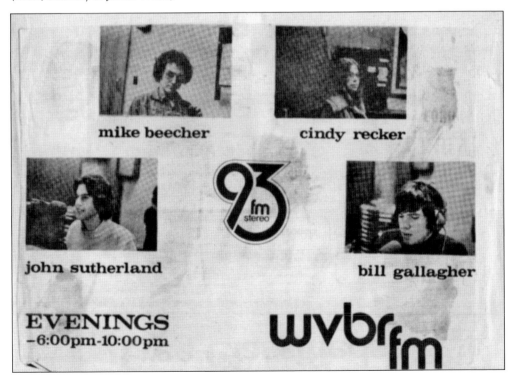

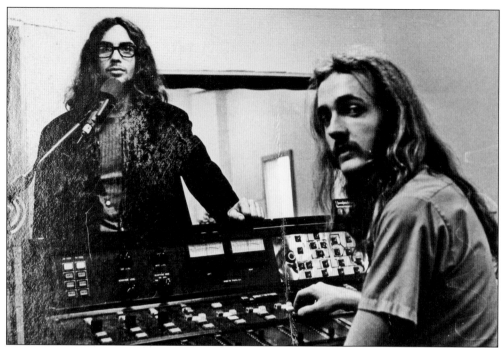

Pat McCabe (left) and Don Boyle are on the air at WVBR in this 1973 picture. (Courtesy of Cornell University Division of Rare and Manuscript Collections.)

WVBR's Carl Goldstein is in the station's record library in 1972. (Courtesy of Cornell University Division of Rare and Manuscript Collections.)

Radio people can be tough on equipment. John B. Hill, pictured here in the late 1970s, was one of several technically talented WVBR staffers who could perform miracles when things went belly-up in the studio or during a remote broadcast. When Hill died in 2009, WVBR alums remembered him on the station's website as kind, unselfish, warm, eccentric, positive, and reliable. (Courtesy of Keith Olbermann.)

Taken at a late 1970s broadcast convention, this photograph shows, from left to right, WVBR's Pat Lyons, legendary WABC New York program director Rick Sklar, WVBR program director Glenn Corneliess, WICB program director Steve Goldstein, and WVBR'S Dave Goldsmith. WVBR's Craig Mustard is looking over Goldsmith's shoulder. (Courtesy of Stacey Cahn.)

The WVBR newsroom is pictured in August 1976 or 1977, according to the ABC News Radio calendar on the wall. Note the use of typewriters. (Courtesy of Cornell University Division of Rare and Manuscript Collections.)

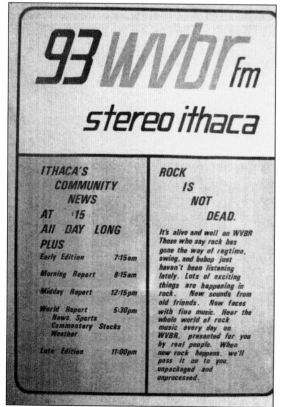

93 wvbr fm

stereo ithaca

ITHACA'S COMMUNITY NEWS AT :15 ALL DAY LONG PLUS	ROCK IS NOT DEAD.
Early Edition 7:15am	It's alive and well on WVBR. Those who say rock has gone the way of ragtime, swing, and bebop just
Morning Report 8:15am	haven't been listening lately. Lots of exciting things are happening in
Midday Report 12:15pm	rock. New sounds from old friends. New faces
World Report 5:30pm News Sports Commentary Stocks Weather	with fine music. Hear the whole world of rock music every day on WVBR, presented for you by real people. When
Late Edition 11:00pm	new rock happens, we'll pass it on to you, unpackaged and unprocessed.

This WVBR ad demonstrates the variety of services offered by the station during the 1970s, while promoting its core—album-oriented rock music. These days, rock radio is not associated with services such as news and sports, but WVBR did it all and did it well. (Courtesy of David Dy Tang, *Ithaca Times*.)

)T ANNOUNCEMENTS

	1x	150x	250x	500x	1000x	1500x	2500x
60 ècond	7.00	5.75	5.25	4.75	4.00	3.75	3.50
30 ècond	5.00	4.50	4.00	3.50	3.00	2.75	2.50

RODUCTORY PLAN
week, non-renewable)

	185x	275x	365x
60 ·cond	4.65	4.50	4.25
30 ·cond	3.65	3.50	3.25

all advertising run of schedule

SPECIAL EVENTS
PROMOTION

	10x	20x	30x	50x
60 second	6.00	5.75	5.50	5.25
30 second	4.75	4.50	4.25	4.00

program rates available upon request

This is a WVBR advertising rate card from 1974, well into the station's first heyday as an album rocker. The top line of each box represents the station's "frequency discount." An advertiser buying 2,500 commercials would pay half the amount per spot as someone who bought a single commercial. (Courtesy of Cornell University Division of Rare and Manuscript Collections.)

WVBR, like many radio stations, handed out discount cards during the early 1980s, encouraging listeners to use them at participating advertisers. Cardholders could get special access to radio station promotions or concerts and, in some cases, free or discounted admission. (Courtesy of Rick Sommers Steinhaus.)

Pictured standing is WVBR general manager Larry Epstein. Epstein later became vice president of finance at CBS and is currently a dean at Drexel University. Seated at lower right is program director Andy Denemark, who later held executive positions at DIR Broadcasting, NBC Radio, and Westwood One and is now vice president of programming for United Stations. This picture was taken in the spring of 1977 in the WVBR staff lounge. (Courtesy of Peter Schacknow.)

The new home for WVBR, the Olbermann-Corneliess Studios, is on East Buffalo Street near Cornell's campus. Keith Olbermann's gift helped complete a $900,000-plus fundraising campaign to finance the move. The building is named for Olbermann's late father, Theodore, and his close friend Glenn Corneliess, former 1970s WVBR program director. It includes a multimedia center where students train in video production and web design. (Photograph by Chris Wheatley.)

Four

WTKO

Founded in 1956 by Woody Erdman, Thomas Cassell, and a group of investors, WTKO at 1470 AM became a staple of the Ithaca radio landscape for the better part of four decades. Broadcasting from the Ivy Broadcasting Building through the early 1970s, the station relocated to 317 North Aurora Street. WTKO signed on the air as a daytime only station at 1,000 watts. In 1974, the FCC authorized 24-hour operation, with a reduced-power (250 watt) directional signal at night. In the late 1970s, WTKO's daytime power increased to 5,000 watts.

On June 6, 1948, eight years before WTKO arrived, Erdman signed on the Rural Radio Network (RRN), an interconnected group of six commercial FM radio stations spread across upstate New York with programming originating in Ithaca. Developed with farmers and croppers in mind, RRN signed on as the first all-radio, no-wireline network in the world servicing the state's thriving agricultural community. The station was located in downtown Ithaca at the Ithaca Savings Bank Building at 306 East State Street.

RRN survived numerous owners and formats until it was broken apart and sold station by station in the early 1980s. The legacy in Ithaca remains at 103.7 FM, which was first known as WRRA, then WEIV, and finally, in the mid-1980s, as WQNY.

In the 1960s and 1970s, WTKO was a prototypical Top 40 machine, complete with a reverbed sound chain to enhance anything that was broadcast on 1470. Known as Tompkins County's Information Station, WTKO took great pride in news coverage of local happenings and Ithaca politics.

Musically, the station resembled other legendary Top 40 stations across the country, like WLS Chicago and WABC and WXLO in New York City, providing the hits as well as a deep library of oldies, which found a place on Sunday night's *Reflections*.

In 2005, the station was sold as part of the package to Saga Communications/ Cayuga Radio Group. With its call letters now WNYY, the station has long abandoned music and now features "progressive talk" with mostly nationally syndicated shows.

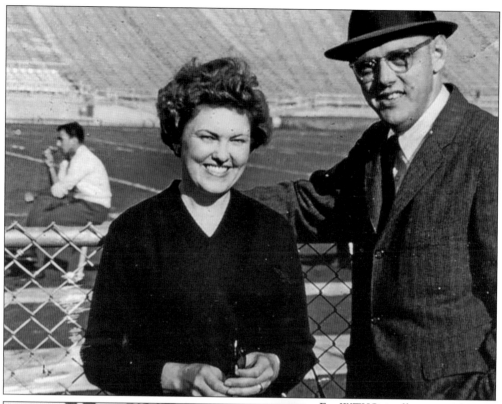

For WTKO, it all starts with Phebe and Ellis E. "Woody" Erdman, who signed on the station with a group of investors during the spring of 1956. Erdman was a sportscaster and a onetime play-by-play announcer for the New York Giants. The "TKO" call letters are a reference to his love of sports, and the "knockout" punch he hoped to deliver to Ithaca radio. Other partners came and went, but the Erdmans owned at least a percentage of WTKO until the early 1980s, when financial difficulties forced them to sell. (Courtesy of Rebecca Edmunds.)

This early 1960s photograph shows Woody Erdman preparing for a remote sports broadcast at Cornell University. The audio mixer at lower left was a part of WTKO sports' remote kit into the late 1970s. (Courtesy of Rebecca Edmunds.)

This is the cover for WTKO's first advertising rate card from the spring of 1956. Note the station information, slogans, and especially the boxing glove logo, which remained a part of WTKO for years. (Courtesy of Wendy Paterniti.)

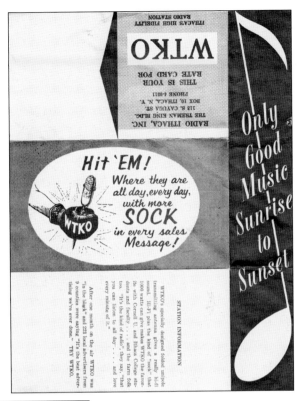

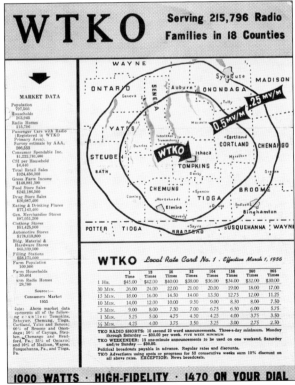

This is the inside of the first WTKO rate card. The coverage map was a bit overstated, as 1,000 watts did not even come close to reaching Syracuse! Note the market data and rates for spots as short as 30 seconds, and the program rates by the hour. (Courtesy of Wendy Paterniti.)

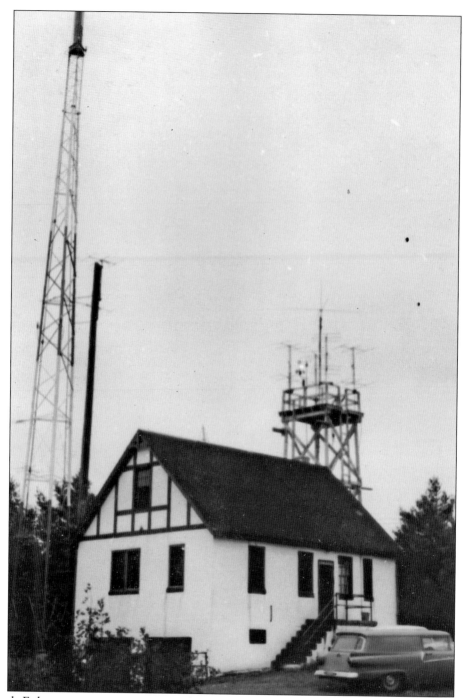

Woody Erdman was an entrepreneur with several broadcasting and real estate enterprises during the 1950s, 1960s, and 1970s. The Rural Radio Network, started in 1948, survived in various incarnations (from agricultural to religious programming) for several decades. By the late 1950s, the statewide network of FM stations was known as the Northeast Radio Network. The stations were sold off individually in the 1980s, long after the Erdmans' ownership. This is WRRA's Ithaca transmission site. (Courtesy of Wendy Paterniti.)

Pictured here is a WTKO remote broadcast from the then-new Jamesway store at Tripphammer Mall in the early 1960s. From left to right are news director Bill Diehl, morning host Andy Andrews, actress Michelle Lee (who was appearing on Broadway, possibly in *How to Succeed in Business Without Really Trying*), an unidentified actor, and an unidentified pianist. Diehl later worked at stations in Washington, DC, and New York, landing at ABC Radio News as a staff correspondent in 1971. He anchored newscasts and covered a wide range of stories before becoming ABC's full time entertainment reporter, and although he retired from full-time work in 2007, he's still heard on ABC Radio as a freelance correspondent. (Courtesy of Bill Diehl.)

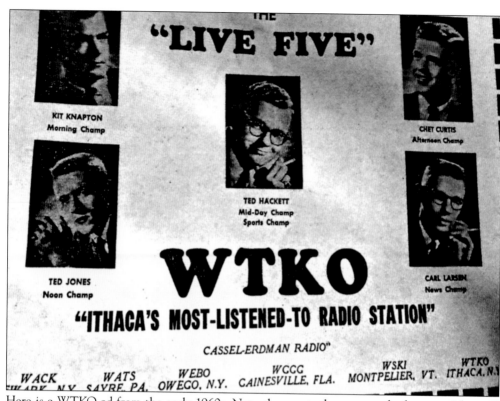

Here is a WTKO ad from the early 1960s. Note the sports theme; everybody was a "champ!" "Cassell-Erdman Radio" refers to partners Thomas Cassell and Ellis E. "Woody" Erdman, who put WTKO on the air in 1956. (Courtesy of Ted Jones and Bill Diehl.)

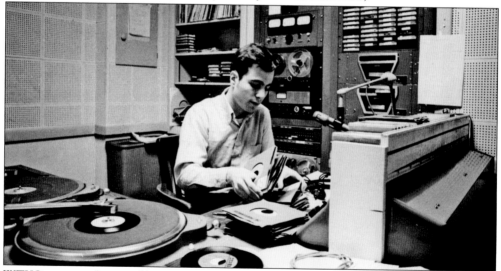

WTKO program director Alan Rosen is seen here on the midday shift, from 11:00 a.m. to 3:00 p.m., in 1968. Rosen later worked at WABC New York and WLS Chicago as the engineer for radio legends like Bruce Morrow, Dan Ingram, Larry Lujack, and John "Records" Landecker. In 1976, Rosen joined CBS and WBBM-AM and -FM for 35 years as a technician. Now retired from full-time work, he still engineers Chicago Bears broadcasts for WBBM. (Courtesy of Steve Schwartz.)

THIS WEEK	LAST WEEK	TITLE	ARTIST
1	1	GET BACK	BEATLES (APPLE)
2	3	LOVE	MERCY (SUNDI)
3	8	OH HAPPY DAY	EDWIN HAWKINS SINGERS (PAVILION)
4	6	THESE EYES	GUESS WHO (RCA)
5	7	MORNING GIRL	NEON PHILHARMONIC (W-7)
6	5	ATLANTIS	DONOVAN (EPIC)
7	10	DAY IS DONE	PETER, PAUL & MARY (W-7)
8	18	GRAZING IN THE GRASS	FRIENDS OF DISTINCTION (RCA)
9	12	IN THE GHETTO	ELVIS PRESLEY (RCA)
10	16	BAD MOON RISING/LODI	CREEDENCE CLEARWATER (FANTASY)
11	11	WHERE'S THE PLAYGROUND, SUSIE	GLEN CAMPBELL (CAPITOL)
12	17	TOO BUSY THINKING	MARVIN GAYE (TAMLA)
13	9	GOODBYE	MARY HOPKIN (APPLE)
14	20	ONE	THREE DOG NIGHT (DUNHILL)
15	---	LOVE THEME FROM ROMEO & JULIET	HENRY MANCINI (RCA)
16	4	THE BOXER	SIMON & GARFUNKEL (COLUMBIA)
17	29	DON'T LET THE JONESES	TEMPTATIONS (GORDY)
18	23	HEATHER HONEY	TOMMY ROE (ABC)
19	22	WINDMILLS OF YOUR MIND	DUSTY SPRINGFIELD (ATLANTIC)
20	27	BLACK PEARL	SONNY CHARLES (A&M)
21	30	LET ME	PAUL REVERE & RAIDERS (COLUMBIA)
22	2	HAIR	COWSILLS (MGM)
23	31	SEE	RASCALS (ATLANTIC)
24	PH	GOOD MORNING STARSHINE	OLIVER (JUBILEE)
25	25	IT'S NEVER TOO LATE	STEPPENWOLF (DUNHILL)
26	21	EVERYDAY WITH YOUR GIRL	CLASSICS IV (IMPERIAL)
27	---	SO I CAN LOVE YOU	EMOTIONS (VOLT)
28	---	MOODY WOMAN	JERRY BUTLER (MERCURY)
29	15	I CAN'T SEE MYSELF	ARETHA FRANKLIN (ATLANTIC)
30	---	MY PLEDGE OF LOVE	JOE JEFFREY GROUP (WAND)
31	26	PINBALL WIZARD	WHO (DECCA)

WTKO's Top 31 Sound Survey for May 21, 1969, is pictured. At least 20 of the 31 hits remain staples of radio's oldies formats today! (Courtesy of Bob Kur.)

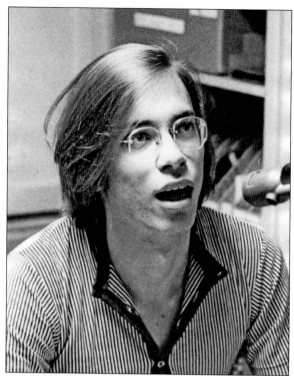

WTKO had many rocking jocks in the 1960s and 1970s, but the Greaseman was the most famous and most outrageous of them all! Doug Tracht says he took the nickname after a coworker commented that he was "cookin' with grease!" Future stops in Tracht's career included long tenures in Jacksonville, Florida, and Washington, DC, where he was also nationally syndicated. He is shown here in 1971. (Courtesy of Doug Fincke.)

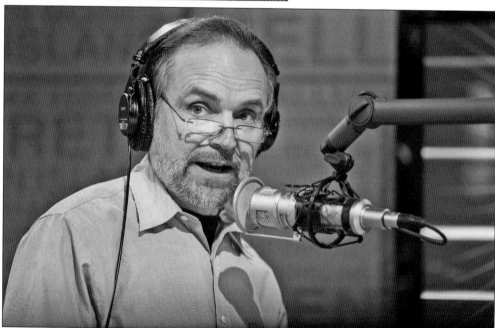

One of WTKO's alums who became nationally known is Dave Ross, a 1973 Cornell graduate who worked at WTKO as a reporter and news director. Ross reported for five years at legendary WSB-AM Atlanta. In 1978, he joined Seattle's KIRO-AM as a reporter. In 1987, Ross began hosting his own talk show, which now airs in morning drive. He also provides daily commentaries for the CBS Radio Network. Ross is shown here in 2013. (Courtesy of Dave Ross.)

From the early 1970s to 1981, brother and sister Bob and Marcia Lynch led a fully staffed news department in covering Ithaca and Tompkins County 24-7. They both served as WTKO news directors, while Bob later became the station's program director and operations manager. Their abrupt dismissals in 1981 dismayed many area leaders, who praised their hard-hitting but fair reporting. They are seen here in 2013. (Photograph by Peter King Steinhaus.)

WTKO's home from 1956 to the early 1970s was this building at 213 South Cayuga Street. Woody Erdman's enterprises changed names several times during his ownership of the station, and more than 30 years after Ivy Broadcasting last appeared on anything "official," the building and this sign were still standing in 2013. (Photograph by Peter King Steinhaus.)

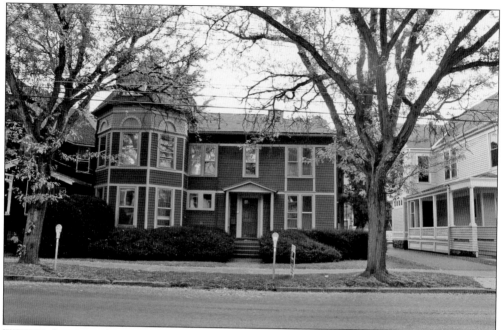

WTKO's home in the 1970s and early 1980s was at 317 North Aurora Street. The newsroom and studios were on the first floor. Note the parking meters in the 1970s. WTKO disc jockey Jim Roberts was known for accumulating dozens of parking tickets each year, and for his admonition, "watch out for the meter maids!" (Photograph by Peter King Steinhaus.)

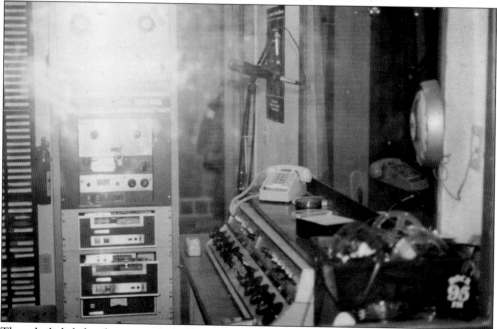

Though slightly hard to see with the bright light, WTKO's production studio is pictured, with its two ancient, but working, Ampex reel-to-reel tape decks; two less-ancient Gates tape cartridge machines; and a Gates control board. This view is from WTKO's on-air studio, from the early 1980s. (Courtesy of Wendy Paterniti.)

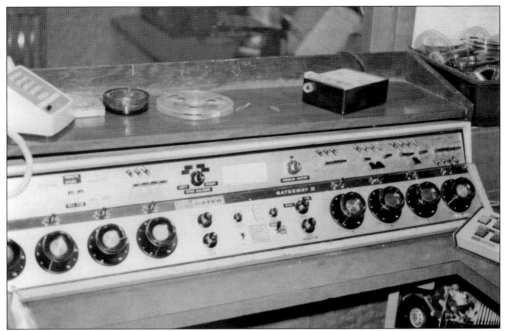

Here's WTKO's production studio, with a good look at a radio classic. The Gates "Gateway II" audio console was the mainstay for many radio stations in the 1970s. The object sitting on the top right of the audio console is a bulk eraser for reel-to-reel tapes and tape cartridges. Note the ashtray near the phone, a sign of the times! (Courtesy of Wendy Paterniti.)

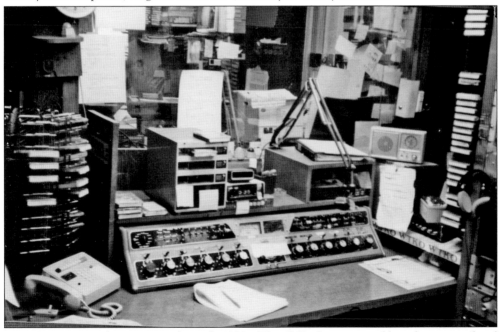

WTKO's on-air studio is seen in the early 1980s. The 1950s Gates control board was considered vintage when it was used in the 1970s and 1980s, but engineers Dominick Bordinaro (aka Dr. Don Gray) and David Matthews kept it in top working condition. The WTKO newsroom is on the other side of the glass; it was about the size of three phone booths. (Courtesy of Wendy Paterniti.)

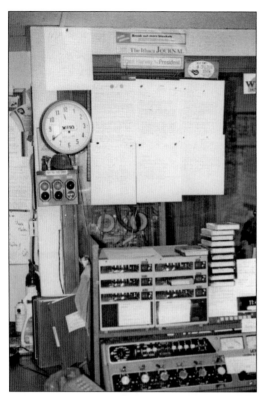

WTKO's on-air studio is pictured in the early 1980s. Sitting on top of the control board are two ITC triple-spot cartridge machines, which were essential to the studio. WTKO often ran more than the National Association of Broadcasters–sanctioned 18 minutes of commercials per hour during the early 1980s, plus jingles and music on cartridges, so every slot was needed! The lights under the clock lit up when the phones rang (the ringers were muted). (Courtesy of Wendy Paterniti.)

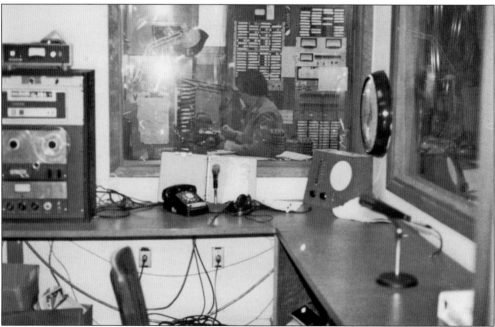

Pictured in the early 1980s is the WTKO talk studio with its view into the on-air control room. WTKO's daily *Ithaca Today* public affairs show originated from this studio. Hundreds of interviews were recorded here, and during big snowstorms, a second on-air person usually read scores of school closings and cancellations from this room. (Courtesy of Wendy Paterniti.)

WTKO's Big Jim Roberts is riding an elephant. This was a July 1977 promotion called the "Great Elephant Race," held in the parking lot of the then-new Pyramid Mall on Tripphammer Road. (Courtesy of Deborah Donnelly.)

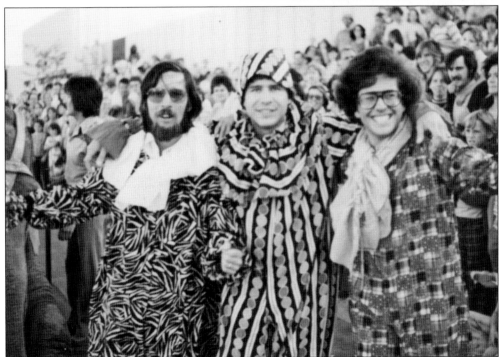

From left to right, afternoon jock Big Jim Roberts, midday man Don Harvey, and nighttime rocker Peter King Steinhaus (who had the biggest hair on the WTKO staff) are all dressed up for the Great Elephant Race of July 1977. It drew a crowd of hundreds of Ithacans anxious to see if three disc jockeys could survive riding on the backs of thundering pachyderms. They did. (Courtesy of Peter King Steinhaus.)

This is a 1977 WTKO bumper sticker. The rising sun was bright yellow. (Courtesy of Paul Harvey.)

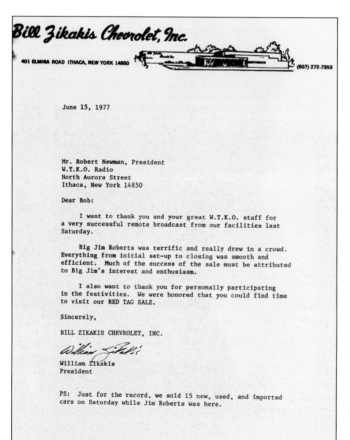

WTKO billed itself as "Tompkins County's Number One Radio Station" and worked hard to live up to that reputation with its advertisers. Here is a testimonial from Chevrolet dealer Bill Zikakis after a Big Jim Roberts remote broadcast. (Courtesy of Wendy Paterniti.)

WTKO broadcast Ithaca College football during the 1970s, with Red Parton and Ernie Jackson calling the play-by-play and color, respectively. This WTKO ad touting the station's programming and services appeared in the Ithaca College game program during the fall of 1978. (Courtesy of Martin Gould.)

RADIO · 1470 · ITHACA

MUSIC AND NEWS 24 HOURS A DAY
ITHACA'S NUMBER 1 COMMUNITY STATION

YOUR CENTER FOR INFORMATION:

MORNINGS: 15 newscasts and 10 sportscasts between 5 a.m. and 10 a.m. More than any other station.

COMMUNITY NEWS: WTKO's "Billboard" runs throughout the day. For free publicity, mail items to WTKO, Box 10, Ithaca.

WEATHER, SPORTS, MOVIES: the WTKO Information Phone is available 24 hours a day at 273-3660.

BEST NEWS TEAM IN TOWN: News on the hour 24 hours a day. Major newscasts at 6:55 a.m., 7:55 a.m., 12:05 p.m., 3:55 p.m.; 4:55 p.m., 5:55 P.M., and 10:55 p.m.

LOST ANIMALS: hear the SPCA report on lost and found animals and pets for adoption each morning at 11:30 a.m.

CANCELLATIONS: School closings, flight cancellations, postponements all heard first on WTKO.

MUSIC: The best contemporary music 24 hours a day presented by the friendliest personalities in town.

SPORTS SCORES: Get the latest scores every Saturday night from 7:00-11:00 p.m. on WTKO's Sports Hotline at 272-1470.

WTKO, HONORED BY AMERICA'S BROADCASTERS AS ONE OF THE NATION'S BEST RADIO STATIONS.

"Follow the Bombers all season long on WTKO"

The 1970s meant rock and roll in the nighttime on WTKO, with personalities like the Greaseman, Dr. Don Gray, Jan Michaels, Peter King Steinhaus, Steve Morris, Alan Nelson, Rich Yelen, and Ricky King. In the late 1970s, Debbie Rich, pictured here, played the hits on weekday evenings. (Photograph by Peter Schacknow.)

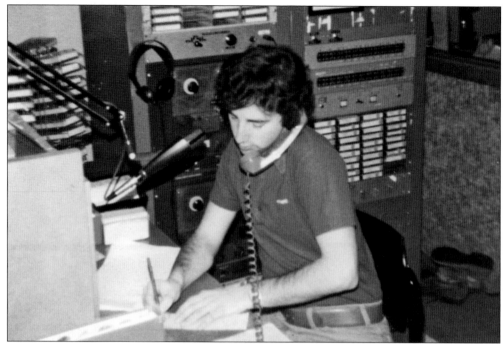

WTKO had some pretty outstanding overnight jocks in the 1970s, ranging from Chuck Reynolds to Don Harvey to Jim Keller, pictured on the air here. Looks like he is taking a listener's request or writing down instructions from the boss. (Photograph by Peter Schacknow.)

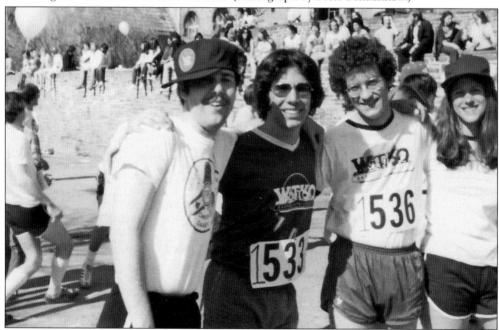

The WTKO team held its head high at the 1980 Phi Psi 500, a pub-crawl disguised as a running event! From left to right are disc jockeys Dave Smith, author Rick Sommers Steinhaus (known at the time as "Ricky King"), morning man Steve Morris, and Cynthia Parker. (Courtesy of Rick Sommers Steinhaus.)

WTKO was a family affair for the "Kings." Author Peter King Steinhaus worked there from 1976 to 1978. His brother, Rick, who took the air name "Ricky King" in 1979, held down the evening and afternoon shifts for nearly two years. He is shown here during the spring of 1981. Rick later changed his air name to Rick Sommers and became a fixture on New York City's WLTW-Lite FM during the 1990s and 2000s. (Courtesy of Rick Sommers Steinhaus.)

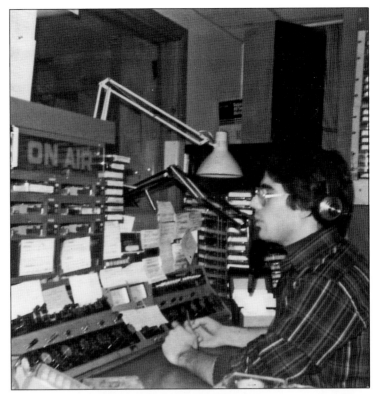

WTKO middays in the 1970s included Mark Mercer (1974–1975), Dave Drummond (1975–1976), Don Harvey (1976–1978), and Billy Williams (1978–1979), pictured here. (Photograph by Peter Schacknow.)

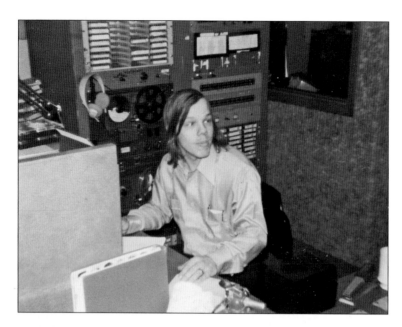

WTKO afternoon jock Wayne Carlson is pictured in the late 1970s. (Photograph by Peter Schacknow.)

Glenn Withiam, WTKO anchor-reporter, is seen in the late 1970s. He worked at WVBR and WTKO in the early 1970s but left for Albany. Later, he was persuaded to return by news director Marcia Lynch. Fellow WTKO news reporter Peter Schacknow says, "I was lucky enough to work with and learn from him. A true pro and a great guy." (Photograph by Peter Schacknow.)

WTKO participated in hundreds of community events over the years. Donkey basketball at local high schools was always a popular fundraiser. This photograph is from March 1986. (Courtesy of Wendy Paterniti.)

WTKO and WQNY-FM "The Wave" sometimes did joint promotions like the listener event shown here. One van for both stations insured that WTKO, "the Information Station," and rock and roller "The Wave" were always promoted together. WQNY dropped rock for country in 1996. (Both, courtesy of Wendy Paterniti.)

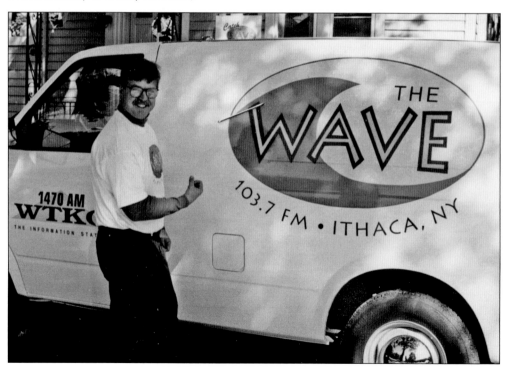

This coffee mug is from one of WTKO's last incarnations as a music station, when it played Oldies. Oldies were a big part of WTKO's heritage, which included the Sunday night request show *Reflections* during the 1970s. (Courtesy of Ron Volbrecht.)

This WTKO News mic flag is from the 1980s. For many years, WTKO called itself "The Information Station." It was always a good day when a WTKO logo showed up in a television news story or in an *Ithaca Journal* or *Ithaca Times* photograph. (Courtesy of Wendy Paterniti.)

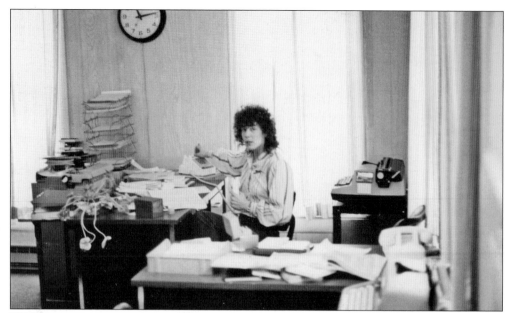

WTKO account executive Wendy Paterniti is pictured in the early 1980s. The desk is crowded with paperwork, reels of commercials, an IBM Selectric typewriter to Wendy's left, and a Smith Corona typewriter in the foreground, which was probably manufactured in nearby Cortland. Wendy started with WTKO in the mid-1970s and, in 2013, was still at it with the Cayuga Radio Group. (Courtesy of Wendy Paterniti.)

As CDs replaced records and tape cartridges in the 1990s, they also replaced cassette tapes at the sales end. This artwork is from a WTKO CD case; the CDs were given to advertisers so that they could have permanent recordings of their commercials. (Courtesy of Rudy Paolangeli.)

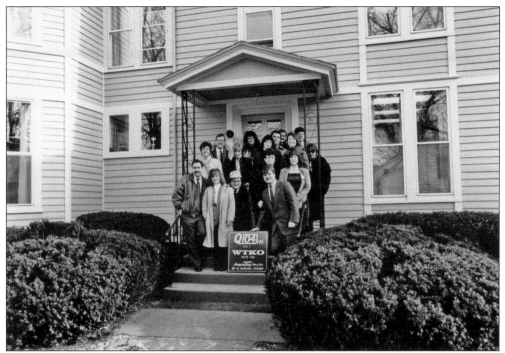

The WTKO/Q-104 staff is pictured in front of the studios and offices at 317 North Aurora Street around 1990. (Courtesy of Wendy Paterniti.)

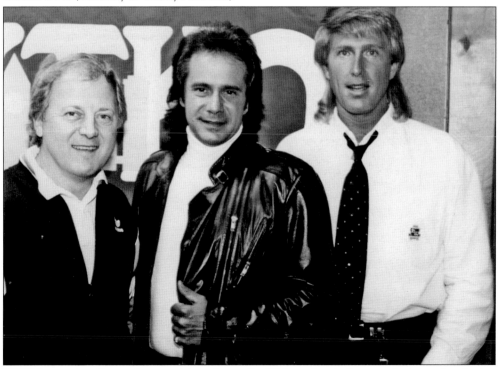

WTKO occasionally got famous visitors in studio. This undated photograph shows the singing group The Lettermen. (Courtesy of Wendy Paterniti.)

This 2008 photograph shows WTKO alum Bill Diehl (left) with Ithaca broadcast and voiceover legend Bob Earle. Bob is most famous for hosting the GE College Bowl from 1962 to 1970 on NBC. The former Ithaca College professor then returned to Ithaca, where he voiced hundreds of commercials and became an executive with the Tompkins County Trust Company. His daughter Mary was a WTKO reporter in the 1980s. (Courtesy of Bill Diehl.)

WTKO legends David Stewart (left) and Bob Kur are seen in this 2013 photograph. They worked together at WTKO during the 1960s. Stewart has had a long and successful career in advertising and public relations and, in 2013, was still heard on Ithaca radio. Kur spent more than 30 years as a Washington-based correspondent with NBC News and then returned to his radio roots at All-News WTOP before retiring to the Ithaca area. (Photograph by Peter King Steinhaus.)

This is a 2013 Ithaca radio reunion! Everyone pictured started at WICB, and 9 of the 14 people shown here worked at WTKO. Pictured are, from left to right, (first row) Janet Green; Corey Taylor; author Rick Sommers Steinhaus, WTKO alumnus; Marty Gould, WTKO alumnus; and author Peter King Steinhaus, WTKO alumnus; (second row) Mark Weiss; Henry Kavett, WTKO alumnus; Glenn Potkowa, WTKO alumnus; Barry Leonard, WTKO alumnus; Cindy (Thomason) Smith, WTKO alumnus; Steve Seidmon; Steve Goldstein, WTKO alumnus; Ed Alpern; and David Lee Miller, WTKO alumnus. Long may they run! (Photograph by Laurie Greenberg.)

DISCOVER THOUSANDS OF LOCAL HISTORY BOOKS
FEATURING MILLIONS OF VINTAGE IMAGES

Arcadia Publishing, the leading local history publisher in the United States, is committed to making history accessible and meaningful through publishing books that celebrate and preserve the heritage of America's people and places.

Find more books like this at
www.arcadiapublishing.com

Search for your hometown history, your old stomping grounds, and even your favorite sports team.

Consistent with our mission to preserve history on a local level, this book was printed in South Carolina on American-made paper and manufactured entirely in the United States. Products carrying the accredited Forest Stewardship Council (FSC) label are printed on 100 percent FSC-certified paper.